DARK HISTORY OF
PENN'S WOODS

DARK HISTORY OF PENN'S WOODS

Murder, Madness, and Misadventure in Southeastern Pennsylvania

JENNIFER L. GREEN

BROOKLINE
books
Havertown, Pennsylvania

Brookline Books is an imprint of Casemate Publishers

Published in the United States of America and Great Britain in 2021 by
CASEMATE PUBLISHERS
1950 Lawrence Road, Havertown, PA 19083, USA
and
The Old Music Hall, 106–108 Cowley Road, Oxford OX4 1JE, UK

Copyright 2021 © Jennifer L. Green

Paperback Edition: ISBN 978-1-95504-100-3
Digital Edition: ISBN 978-1-95504-101-0

A CIP record for this book is available from the British Library

Printed and bound in the United States by Integrated Books International

For a complete list of Brookline Books titles, please contact:

CASEMATE PUBLISHERS (US)
Telephone (610) 853-9131
Fax (610) 853-9146
Email: casemate@casematepublishers.com
www.casematepublishers.com

CASEMATE PUBLISHERS (UK)
Telephone (01865) 241249
Email: casemate-uk@casematepublishers.co.uk
www.casematepublishers.co.uk

For my husband, who has shown great fortitude in the face of my growing collection of books about murder.

Contents

Introduction:
"Our Evil Twin, Our Shadow"

The documented history of the strange and tragic in Delaware and Chester counties began when the first ships under the command of white Europeans sailed into the Delaware Bay. Henry Hudson, captain of the Dutch East India Company flyboat *Halve Maen* ("Half Moon") stumbled upon the Delaware Bay in 1609 during his search for a northwest passage to Asia. The crew soon discovered treacherous shallows hidden beneath the calm waters of the Delaware River, and decided to turn around and head back out to sea. Hudson's short jaunt was enough for the Dutch to lay claim to the area, and he returned in 1610 (aboard the English ship *Discovery*) to do more exploring. After a brutally cold and miserable winter spent off the east coast of Canada, Hudson's crew mutinied and set him and his allies adrift in a lifeboat, never to be heard from again.

The tragedies continued in the following decades. In 1629, the Dutch negotiated the purchase of land in southern Delaware from the local indigenous peoples and planted a small colony of 28 settlers called Zwaanendael. The colony was soon destroyed in a conflict with the Native Americans. Later, the Dutch decided to move their settlements to New York, which allowed the Swedes to take over the Delaware River Valley. In 1643–44 the Swedish settlement on Great Tinicum Island, under the command of Johann Printz, met with a disastrous number of deaths from overwork and starvation. Twenty years later, in 1667, the English wrested control of the Delaware Bay from both the Dutch and the Swedes and in 1681, King Charles II granted William Penn (1655–1718) a generous charter naming him as proprietor of what would eventually become Pennsylvania. Giving Penn a charter

for such a vast territory satisfied two of Charles II's goals—to repay an enormous debt that he owed to Penn's father, and to peacefully oust the troublesome Quaker and his coreligionists from England. Penn's first voyage to his new home in 1682 was shadowed by an outbreak of smallpox aboard the *Welcome* which killed 30 of Penn's 100 emigrant companions en route.[1] Instead of making the Penn family rich, Pennsylvania turned out to be a money pit that landed Penn in debtor's prison at the end of his life. Under no circumstances could this be considered an auspicious beginning.

Despite its troubled start, Pennsylvania soon developed a glowing reputation in the world as a beacon of freedom, equality, and prosperity. William Penn negotiated treaties with the local Lenni Lenape tribe, setting the stage (at least theoretically) for a peaceful coexistence with the native peoples. He then set about establishing what he considered to be a political utopia guaranteeing free and fair trial by jury; freedom of religion; freedom from unjust imprisonment; and free elections. He denounced the "Bloody Code," the legal system under which England operated at the time, which used execution as a form of punishment for crimes as diverse as theft, using a disguise while committing a crime, and "being in the company of Gypsies for one month."[2]

Europeans praised Penn's experiment as launching a golden age of humanity. The Abbé Raynal gushed that this "Republic without wars, without conquests, without effort ... became a spectacle for the whole universe."[3] Evangelist George Whitefield praised the region: "Their oxen are strong to labour and there seems to be no complaining in their streets The Constitution is far from being arbitrary; the soil is good, the land exceedingly fruitful, and there is a greater equality between the poor and rich than perhaps can be found in any other place of the known world."[4]

Beneath the golden mantle of utopia, however, seethed an underbelly of dissent, frustration, and violence. As early as 1693, the Provincial Council complained that Pennsylvanians were already violating Penn's proclamations against "Sabbath breaking, drunkenness, Idleness, Unlawfull gaming, and all manner of prophanesse."[5] The looseness of the

laws in Pennsylvania seemed to encourage settlers to break them even more frequently. In hindsight, we can understand why diverse groups of immigrants from Germany, Ireland, Scotland, and elsewhere might not lovingly embrace the Quaker strictures against gambling, dancing, fancy dress, and theater. Staidness is not everyone's cup of tea. The quandary over what laws to require which immigrants to follow ended up crippling law enforcement of any kind. What started out as small moral infractions in the late seventeenth century mushroomed into theft, violence, and rioting in the eighteenth century.

Jack D. Marietta, a historian of crime and punishment in Pennsylvania, crunched the numbers and discovered that 513 homicide cases were brought to court by 1801. This number far exceeded any other British colony except Virginia, which had a far larger population. In the 1720s, Pennsylvania's homicide indictments outstripped even London's worst rates in the eighteenth century. One particularly bloody decade was the 1780s, after the seismic cultural and political shifts of the Revolutionary years, when courts tried 136 suspected cases of murder in just ten years—more than the colony of Massachusetts tried in the previous 50.[6] Blame often fell upon new surges of German and Scot-Irish immigrants, who didn't subscribe to Quaker pacifism, and commonly hailed from areas with a long history of violence and upheaval.

In an ironic twist, in the eighteenth century the English government made an effort to stop executing so many people for so many crimes, but their solution was to ship them off to the colonies with the explanation that a change of scenery might make them hardworking, honest individuals. An irate Benjamin Franklin, writing in *The Pennsylvania Gazette* in 1751, observed with dripping sarcasm that if the British were content to send their criminals to Pennsylvania for a change of climate, then Pennsylvanians should send the British some rattlesnakes:

> In some of the uninhabited Parts of these Provinces, there are Numbers of these venomous Reptiles we call Rattle-Snakes These, whenever we meet with them, we put to Death, by Virtue of an old Law, *Thou shalt bruise his Head*. But as this is a sanguinary Law, and may seem too cruel; and as however mischievous those Creatures are with us, they may possibly change their Natures, if they were to change the Climate; I would humbly propose, that this general Sentence of Death be changed for *Transportation*.[7]

Times of war and economic depression contributed greatly to the rates of violence in Pennsylvania, including incidents of suicide. In the eighteenth century the British legal system considered suicide to be equally as heinous as murder, and just as disruptive to the peace of the state. In the fourteenth and fifteenth centuries, those who committed "self-murder" were tried posthumously by a coroner's jury and, if convicted, were denied a proper burial and the Crown confiscated all of the victim's worldly goods. By the mid-1700s in Pennsylvania, such coroner's juries generally softened their verdicts by declaring the victims insane rather than guilty of self-murder. In 1795, a man named William Mee hanged himself in East Nantmeal Township, Chester County, and the coroner's report noted the following:

> [He] came to his death not haveing the fear of God before his eyes but being moved and seduced by the instigation of the Devil did in the township aforesaid with a short rope one end thereof then and there put about his neck and the other end thereof he tied about a rafter over the hay mow ... himself then and there with the rope affores[aid] voluntary and feloniously and of his malice forethought himself killed strangled & murdered against the peace of the Commonwealth ...[8]

Harming oneself seemed to have been much more taboo than harming one's family, especially in an era when a certain level of violence or "control" of wives and children was not only permitted, but expected. Systemic violence within families was so commonplace that handbooks for sheriffs advised that parents were allowed to strike children, masters could hit servants, and teachers could inflict punishment on students and still be well within the letter of the law. The wording of the legislation gave significant leeway to the interpretation of "battery" by defining it as the "wrongful beating [of] another."[9] *Wrongful* being the operative word—who was to judge what level of abuse was wrongful?

Like domestic abuse, sexual assault was a form of violence that probably happened far more often than was recorded in court cases. Single women who were raped might have been too afraid or embarrassed to report it, knowing that they would face male lawyers, male judges, and male jurors if the case went to court. The idea of rape between married individuals remained nebulously defined and rarely prosecuted, since women "belonged" to their husbands and were expected to fulfill

their conjugal duties upon demand. Further hampering prosecution for marital rape was the fact that husbands and wives could not legally testify against each other, so such cases depended on the testimonies of friends or neighbors who often were not privy to, or were embarrassed to discuss, such a sensitive matter.

Children were the victims of a horrifying number of sexual assaults in eighteenth-century Pennsylvania. As Jack Marietta observed, "In Chester County, there were 33 cases of rape or attempted rape through 1800. Seven of the thirty-three assaults, or one in five, were upon children 12 years old or younger. The actions of assailants were as depraved as most times and places could supply—and this was in Chester County, with the highest proportion of nonviolent people in Pennsylvania, or all of early America."[10] Sometimes sexual assault of minors was explained away as simply being part of the courtship process; as long as it ended in marriage, the matter could be resolved without involving the courts.

Of the dichotomy of peace and violence in Pennsylvania, historian Lawrence Friedman observed that crime "flows largely from changes in the culture itself; it is part of us, our evil twin, our shadow; our own society produced it."[11] In the case of southeastern Pennsylvania, its very liberty and openness contributed to its violence, its mysticism, and its complex solutions to societal issues. Every utopia requires sacrifice, and the people of southeastern Pennsylvania have paid a blood price more sinister and strange than you might think.

Notes

1 Henry Graham Ashmead, *History of Delaware County, Pennsylvania* (Philadelphia: L. H. Everts & Co., 1884), 20.

2 Paul Lawrence and Barry Godfrey, *Crime and Justice Since 1750* (United Kingdom: Taylor & Francis, 2014), 72.

3 Abbé Raynal, quoted in Charles Shearer Keyser, *Penn's Treaty with the Indians* (Philadelphia: David McKay, 1882), 99.

4 George Whitefield, *Journals 1737–1741,* intro by William V. Davis, 1969, quoted in Jack D. Marietta and G. S. Rowe, "Violent Crime, Victims, and Society in Pennsylvania, 1682–1800," *Pennsylvania History: A Journal of Mid-Atlantic Studies,* Vol. 66, Explorations in Early American Culture (1999), 24.

5 *Minutes of the Provincial Council of Pennsylvania, From the Organization to the Termination of the Proprietary Government,* Vol. 1 (Philadelphia: Jo. Severns & Co., 1852), 371.

6 Jack D. Marietta and G. S. Rowe, "Violent Crime, Victims, and Society in Pennsylvania, 1682–1800," *Pennsylvania History: A Journal of Mid-Atlantic Studies,* Vol. 66, Explorations in Early American Culture (1999), 26–27.

7 "Felons and Rattlesnakes, 9 May 1751," *Founders Online,* National Archives, https:// founders.archives.gov/documents/Franklin/01-04-02-0040. (Original source: *The Papers of Benjamin Franklin,* Vol. 4, *July 1, 1750, through June 30, 1753,* ed. Leonard W. Labaree. New Haven: Yale University Press, 1961), 130–133.

8 William Mee Coroner's Report, May 14, 1795, Chester County Archives (West Chester, PA).

9 Jack D. Marietta and G. S. Rowe, *Troubled Experiment: Crime and Justice in Pennsylvania, 1682–1800* (Philadelphia: University of Pennsylvania Press, 2006), 148.

10 Ibid., 145.

11 Lawrence M. Friedman, *Crime and Punishment in American History* (New York: Basic Books, 1993), 464.

Demon, Witch, Cannibal: Pennsylvania's Early Settlers and the Supernatural

For fans of everything spooky, Pennsylvania has a reputation as an unmitigated disappointment. Massachusetts has its witch trials; New Jersey has its Jersey Devil; North Carolina has an armada of ghostly shipwrecks; and sixteenth-century Virginia mysteriously lost the entire colony of Roanoke.[1] By comparison, the Quaker State seems positively dull—until you take a look beneath the surface. The relationship that early Pennsylvanians had with the metaphysical was notable, not because of the *extremity* of it, but because of the eerie *banality* of it. Because of the way the colony developed, Pennsylvanians had a much different approach to the unexplainable than their counterparts in the other 13 colonies.

For most people, the top of the supernatural pyramid is, and has always been, witches. Any study of witchcraft and magic in Chester and Delaware Counties must start with England, from which a majority of Pennsylvania's early residents hailed. During the reign of Elizabeth I (1533–1603), the English view of witchcraft was surprisingly ambivalent, especially given the horrors burning their way across parts of Europe and Scotland during the same period. Granted, England had just emerged from an era of religious tumult that resulted in the first reigning Queen of England gaining the moniker "Bloody Mary" for burning over 300 religious dissenters at the stake during her five-year reign, so perhaps a time of relative quiet was in order.

Queen Elizabeth I executed her fair share of religious dissenters, make no mistake—but her target was Catholics, who she felt were actively trying to overthrow her government. The savvy Elizabeth charged these dissenters with treason, thus shifting the context of their crimes

from religious to civic. Since witches were evidently uninterested in overthrowing the government, they managed to avoid much persecution during the reign of The Virgin Queen, and even when they were convicted for practicing witchcraft, their treatment tended to be more relaxed. Capital punishment was usually reserved for accused witches whose actions resulted in serious injury or death to another human being, as opposed to more benign activities like bewitching cows, flying on brooms, and appearing in spectral form. In addition, the English were unlike other European countries in that they banned the use of torture to extort a confession—at least for witchcraft. Again, suspicion of treason was another matter entirely and extracting information through torture was the accepted practice.

In Scotland, the occult landscape was much different. England's northern neighbor underwent a bloody religious revolution in 1560, converting from a Catholic country that hated witches into a rabidly Presbyterian country that turned hating witches into a gruesome art.

Although King James (1566–1625) had his disagreements with the Presbyterians (namely, their dislike of being ruled by a monarch) they could

 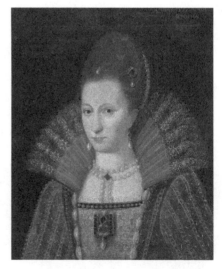

James I of England (c. 1605) and his Queen, Anne of Denmark. (Wikimedia Commons)

at least agree on the treatment of witches within Scottish borders. When the journey to Scotland of James' intended bride, Anne of Denmark, was beset by storms that pummeled her fleet and forced her to take refuge in Norway in 1589, both James and the Presbyterian government agreed that the catastrophe was clearly the work of witches. In 1590, James imprisoned more than 70 people on the charge of raising the storms that almost succeeded in killing Scotland's new queen, and most confessed under torture. Nine years later, James became the first monarch in history to write a treatise on witchcraft, which he called *Daemonologie*. In 1603, he inherited the throne of England, and he brought the brutal Scottish approach to witch-hunting with him. Where England had only executed witches whose acts had resulted in physical harm to a victim, James' government deemed the practice of *any* form of witchcraft a cause for execution. Simply having the "devil's mark," which could be any mole, freckle, scar, or imperfection anywhere on an accused witch's body, might result in a death sentence.

James died in 1625, after years of increasingly debilitating arthritis, gout, and kidney stones that rendered him a pathetic figure in his own court and resulted in a serious stroke that finally took his life. During his decline, the rise of intellectualism and scientific inquiry dampened the public's enthusiasm for

Title page of *Daemonologie* by King James I, published in 1603. (Wellcome Library, London. Wellcome Images images@wellcome.ac.uk http://wellcomeimages.org. Wikimedia)

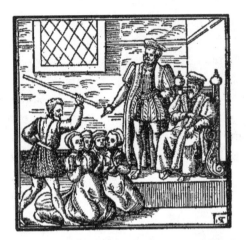

Illustration of witches, perhaps being tortured before James I, from his *Daemonologie*. (Wikimedia)

witch-hunting, and England entered a brief period of calm. The relief was short-lived as his son Charles I ignited an internecine conflict that began the moment he ascended the throne and escalated in the 1640s into a civil war. England was already primed for witch fever when a man named Matthew Hopkins, a self-appointed "Witchfinder General," appeared in East Anglia in 1645 and promptly set off the worst period of demonic hysteria in England's history.

The eastern part of England was home at the time to a population of rabid Puritans for whom even the faintest whiff of heresy threatened their entire community, and due to the civil war there were no royal officials with enough power to keep them in check. Hopkins preyed on the Puritanical fears of hellfire and brimstone, using such "evidence" as moles, warts, or even fleabites as proof of congress with the devil. In Bury St. Edmunds alone, no fewer than 68 people were put to death for witchcraft; the citizens of Chelmsford hanged 19 people in a single day.

Hopkins' reign of terror even made its way to the New World, as his witch-hunting manual, *The Discovery of Witches*, was first published in 1647 and shipped overseas. Almost immediately the Massachusetts Bay Colony copied his techniques in the trial of Margaret Jones in 1648—the first woman executed in that colony for witchcraft. In a perhaps wishful revisionist history of Hopkins' death, a story developed that Hopkins was subjected to his own swimming test and executed as a witch by the same Puritans for whom he'd acted as firebrand. Sadly, this is untrue—he died in 1647 at his home in Manningtree, Essex of pleural tuberculosis and was buried at the Church of St. Mary at Mistley Heath.

While England was going up in flames (both proverbial and literal) the French took a somewhat more whimsical view of witchcraft as a

technical but generally harmless evil. The court of Louis XIV became famous for its use of fortune tellers, seances, and other naughty metaphysical diversions. The fun and games of the court's mystical obsessions provided a glossy veneer for its sinister underbelly, in which people were dying in the name of demonic power. In 1675, a French aristocrat named Madame de Brinvilliers was brought to trial for the poisoning of her father and two brothers in order to inherit their estates. She was found guilty, beheaded, and her body burned. In the following years French police, led by Nicholas de la Reynie, uncovered witchcraft, black masses, and an entire upper class of French society rife with accusations of poisoning and murder. The *Chambre Ardente* ("Burning Court") executed at least 36 people for witchcraft and/or poisoning, while five were sentenced to the galleys, 23 were exiled and at least 65 men and women were sentenced to prison for life.[2] The whole debacle only ended in 1682 when accusations involving Louis XIV's official mistress led to embarrassing questions about the Sun King himself. He silenced the entire affair with a *lettre de cachet*, essentially an early French gag order.

So it was that William Penn, on the heels of the French witchcraft hysteria and after 40 years of religious upheaval in England, arrived in the New World bearing title to the lands now known as Pennsylvania and Delaware. Penn was an avowed Quaker, which rendered him part of a religious minority that had been persecuted in England with imprisonment, mutilation, and execution. Quakers believed that all men and women were equal in the sight of God and could be touched by His divine light without the aid of a religious leader. They also maintained that the Bible should not be interpreted literally, and opposed any form of religious dogma. This outlook was anathema to Puritans, who valued a literal treatment of the Bible and very strict behavioral parameters. Even in New England, purportedly founded by the Puritans in the spirit of religious freedom, laws against the practice of Quakerism included punishments like having one's ear cut off or having one's tongue bored through with a hot iron. When five Quaker women left the safety of the relatively free-thinking Rhode Island to support their comrades in Boston, officials immediately arrested

The Quaker Mary Dyer being led to her execution on Boston Common on June 1, 1660. She was hanged for repeatedly defying a law banning Quakers from the Massachusetts Bay Colony. (Wikimedia)

them and had them checked for witch's marks. In the Puritan mind, being a Quaker was almost as bad as being a witch. Mother England was concerned enough about the actions of the Boston Puritans that it released a charter that required them to make a vow to protect all Christian sects—except, of course, the Catholics.

With persecution fresh in his mind, William Penn determined that his new colony would be a home for religious freedom. Though Penn heavily recruited from amongst his own population of English Quakers, he also appealed to hardworking emigrants from all over Europe. Penn had a prodigious task ahead of him, because establishing religious liberty was one thing—enforcing it was quite another. Penn would have to navigate all the dangerous waters surrounding religion—who constituted a majority? A minority? What rights could they each expect? What were the limits of a government that legislated based on morality? What property rights and privileges could churches and clergy enjoy? Penn also knew that these questions might not be answered in his own lifetime—he had to lay a proper foundation for his colony without knowing how the final product would mature, and without any successful examples to light his path.[3]

Penn began by celebrating the many ways that the various Christian sects agreed, instead of how they differed. He argued that property and liberty of conscience were natural rights, and that by attacking property in the name of religion the government committed a violation of its central and sacred purpose. He even managed to include England's largely despised Roman Catholics in the Christian fold by sagely observing that "we must give the liberty we ask, and cannot be false to our principles ...

for we would have none suffer for a truly sober and conscientious dissent on any hand."[4]

There was, however, a limit to Penn's religious liberty—his basic tenet required a belief in God in some form. Historian J. William Frost noted that:

> Any individual living in the province who shall "Confess and acknowledge one Almighty God to be the Creator and Upholder and Ruler of the World" and who "Professeth him or herself Obliged in Conscience to live Peaceable and Justly under the Civil Government" shall not be molested for "his or her Conscientious Perswasion or Practice" or obliged to support a place of worship or minister against his persuasion[5]

Lest anyone miss the point, Penn went on to specifically state that his insistence on religious liberty was not intended to allow "looseness irreligion and atheism."[6] Because anyone holding official positions had to profess a belief in the divinity of Christ and the Old and New Testaments, Jews were among those excluded from positions of power.

England's legacy of persecution and suspicion provided a test for Penn's colony within two years after his arrival in October 1682. The controversy revolved around Margaret Mattson, who had arrived in Pennsylvania in 1654 with her husband Nils and a wave of early Swedish immigrant settlers. In 1670, the Mattsons settled on a 100-acre parcel of land located near Ridley Creek in what is now Eddystone, Delaware County, where Mattson developed a reputation as a practitioner of a Finnish form of healing folk magic.

In 1683, Margaret Mattson was accused by several members of her community—and even her daughter-in-law—of crimes including making threats against neighbors, causing cows to give little milk, bewitching and killing livestock, and appearing to witnesses in spectral form (a female neighbor named Gertro [or Yeshro] Hendrickson was also accused of similar crimes). With the horrors of the English witch trials fresh in his memory, Penn prepared to face this new challenge to harmony in his colony. Penn was in a sticky situation, because his colony still fell under English common law, and James I's strident Witchcraft Act of 1604 brought the penalty of death to suspected witches. In order to walk the fine line between English law and his own law, he was going to have to get creative.

Penn took charge of the case himself, selecting a jury of 12 men and appointing an interpreter for Mattson and Hendrickson, who spoke no English. Penn barred the use of prosecution and defense lawyers and he alone conducted the questioning. Folk history maintains that at one point during the trial, Penn asked Mattson whether she had ever ridden through the air on a broom, as witnesses had claimed. Mattson misunderstood the question and answered in the affirmative, and the audience gasped. After a moment of contemplation, Penn announced to the crowd that he was not aware of a specific law against the riding of brooms. This anecdote is not supported by the historical record, but does demonstrate the kind of tightrope-walking Penn had to do.

After the end of testimony, Penn made a closing statement and reminded the jurors of the letter of the law. To our great loss, this statement went unrecorded, because the verdict was quite a mind-blower. The jury found that Mattson was "guilty of having the common fame of a witch, but not guilty in the manner and form as she stands indicted."[7] Essentially, Mattson was guilty of giving cause her for neighbors to *believe* she was a witch, but that she was not guilty of having committed specific acts of witchcraft. She was given a fine and returned to her farm.

This unusual verdict accomplished everything and nothing at the same time, for it did not address the legality or illegality of practicing witchcraft directly, only that the jury could not prove that she had committed the specific injuries of which she'd been accused. She could be thought a witch, and she might actually *be* a witch, but she hadn't injured anyone. But for William Penn, he had dodged a proverbial bullet that could have killed his great experiment in its infancy.

Mattson's trial was the first, but not the last time Quakers had to address what it meant to practice witchcraft in Pennsylvania. Even outside of the question of whether it was evil, most Quakers just didn't see the *point* of being a witch or of prosecuting suspected witches. According to historian David Fischer, "Quakers had no need of the devil to explain the existence of evil in the world, nor any use for geomancy to predict the future. Few believing Christians of any faith have ever shown so little interest in the black arts. Quakers commonly regarded the wrongs of the world as the work of man rather than the Devil—and especially

the product of carelessness, ignorance, and human error."[8] To Quakers, why use witchcraft when you should be able to discover truth using your own inner light?

In 1695, the Concord Monthly Meeting had to address the questions of what constituted witchcraft and if they were in a position to punish it. In the autumn of that year, the monthly meeting met to discuss the activities of Philip and Robert Roman, and in their minutes recorded the following: "Some friends having a concern upon them concerning some young men who came amongst friends to their meetings and following some arts which friends thought not fit for such as profess truth to follow, viz., astrology and other sciences, as Geomancy and Chiromancy and Necromancy, etc. It was debated and the sense of this meeting is that the study of these sciences brings a vail over the understanding and a death upon the life." The meeting then assigned two Friends to discuss the matter with the Romans, whose response was to challenge

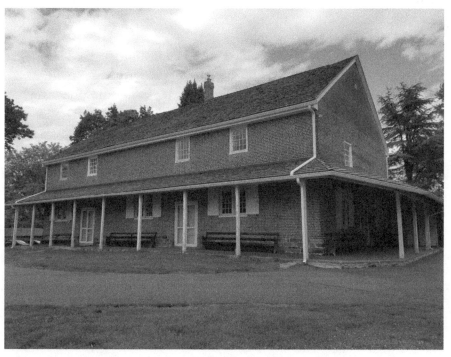

Concord Monthly Meeting Building. (Author)

the meeting to prove to them that what they practiced was wrong, and they would desist.[9]

Finally, the grand jury of Chester County charged Robert Roman for "practising Geomancy According to hidon and Divineng by A sticke."[10] The punishment for practicing the dark arts in this case was a fine of five pounds and a warning to behave better in the future. In addition, three of Roman's books, including Hidon's *Temple of Wisdom*, which taught geomancy, Reginald Scot's *The Discoverie of Witchcraft*, and material by Heinrich Cornelius Agrippa, which explained necromancy, were confiscated and burned. Roman evidently complied with the jury's instruction because he doesn't appear in future records.

Concern about witchcraft in Pennsylvania petered out after 1700. An accusation of witchcraft was brought to the attention of the Council in 1701 but dismissed as trifling.[11] In 1719, the justices of Chester County (which then included Delaware County) inquired into "witchcrafts, enchantments, sorceries, and magic arts," but it does not appear that it was precipitated by a specific incident—more just a general reminder to the public to avoid being witchy.[12]

While witchcraft wasn't officially punished in Pennsylvania, at least one Delaware Countian considered it better to be safe than sorry. In 1976, while excavating in Governor Printz State Park in Essington, workers uncovered an unusual artifact. They found, buried upside down in a small hole, a dark, olive-colored bottle with a gold patina and a hand-whittled wooden plug. Placed under the shoulders of the bottle were a long, thin bone thought to be from a bird, and a redware rim sherd that appeared to come from a small, black-glazed bowl. Stranger still, found inside the bottle were six round-headed pins. Archeologist Marshall Becker concluded that this particular find was the first known example of a "witch bottle" found in America.[13]

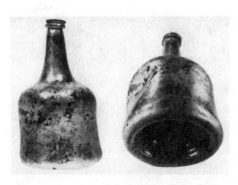

The Essington witch bottle. (Marshall J. Becker)

Other archeological examples of witch bottles had been uncovered in England, so Becker knew what he was dealing with. English witch bottles contained ingredients as complex and varied as nails, human hair, fingernails, blood, urine, wine, rosemary, and even felt cut into the shape of a heart. The bottles themselves

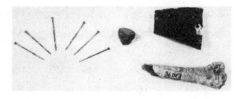

Sealed with a carved wooden plug (center), the Essington witch bottle contained pins (left), a piece of pottery and a bird bone (right). (Marshall J. Becker)

could be made of glass, terracotta, or stone. Witch bottles represented a sort of "white magic" that could either serve as a prophylactic to prevent the general working of magical mischief against the household, or in response to a specific attack. In the case of the former, the bottle would be buried during construction of the house, typically under the hearth or threshold where it would remain undisturbed and unbroken. In the case of the latter, the bottle might be buried outdoors or thrown into a river. The inverted position of the bottle was meant to reverse whatever ill effects the victim suffered back onto the practitioner.

Workers discovered the Essington witch bottle while excavating the Printzhof, the original residence of the Swedish colonial governor Johan Printz, who lived in the colony between 1643 and 1653. The bottle itself was discovered outside of the confines of any known structure, leading Becker to assume that it had been buried to deflect a direct magical attack. Experts dated the bottle's manufacture to around 1740, meaning that it was probably buried by the Taylor family, who lived in the house around that time and hailed from England. What precipitated the burial of the bottle is nearly impossible to guess, but Becker hypothesized that the pins, and the possible presence of urine in the bottle, might indicate that the Taylors thought it could cure bladder stones or some other common urinary ailment, sometimes thought to be caused by witches.[14]

Witch bottle ingredients like nail clippings, hair, and urine indicate a reliance upon the idea of "sympathetic magic," or that a person can be magically affected by a physical representation of their body, like sticking a pin into a voodoo doll. The widespread acceptance of sympathetic magic

in the eighteenth century bridged the gap between the supernatural and the scientific in an astonishing way—the field of "sympathetic medicine." The main difference was that rather than using a symbolic representation of the human body, the afflicted *ingested* parts of the human body in very specific ways.

Proven examples of "medicinal cannibalism" are sparse in the New World but given their prevalence in Europe—and especially England—at the time, it is reasonable to assume that the practice continued in America. Prescriptions using sympathetic medicine could include almost any part of the human body, including blood, bones, fat, and sweat, and were compounded into forms as diverse as teas, tinctures, salves, lotions, and inhalants. A common remedy for migraines might include powdered human skull, just as nosebleeds called for human blood. Animal parts were not considered as effective, since animals lacked the spirit and healing strength imbued by Almighty God.

In an era before germ theory, physicians embraced sympathetic medicine as a reasonable response to diseases otherwise beyond their control. In Galenic medicine, blood was one of the four essential humors, and so it stood to reason that blood was the solution for a depletion or imbalance in that particular area. Even those who did not subscribe to humoral theory touted the benefits of blood; Galen's biggest critic, Paracelsus, believed that drinking blood on certain days and times of the year could cure epilepsy.[15] Sir Theodore Turquet de Mayerne (1573–1655), a physician to no fewer than three English kings (James I, Charles I, and Charles II) and one Protector of the Realm (Oliver Cromwell) published his recipes for popular use. For James I's gout, de Mayerne prescribed "an arthritic powder composed of scrapings of an unburied human skull" with herbs and white wine. He recommended a painkilling plaster made with opium, hemlock, and human fat, and promoted other remedies including the lungs of a man who had died a violent death and the placenta of a woman who has born a male child.[16]

The special healing properties of dead bodies went beyond the mere physical—there also existed a belief in the transmutation of the life force from a deceased individual to a living sufferer through the power of simple touch.[17] An April 19, 1758 issue of *Gentleman's Magazine* reported:

James White, aged 23, and Walter White, his brother, aged 21, were executed at Kennington Common, for breaking open and robbing the dwelling house of farmer Vincent of Crawley. They acknowledged the justice of their sentence, but laid their ruin to an accomplice, who, they declared, decoyed them from their labouring work, by telling them how easily money was to be got by thieving. While the unhappy wretches were hanging, a child about nine months old was put into the hands of the executioner, who nine times, with one of the hands of each of the dead bodies, stroked the child over the face. It seems the child had a wen on one of its cheeks, and that superstitious notion, which has long prevailed, of being touched as before mentioned, is looked on as a cure.[18]

"Stroking," or being healed by the touch of a deceased individual, was thought to transfer healing energy that remained in the body immediately after death, especially in those for whom life had been cut short far ahead of their natural time—like executed criminals. Since newspapers published the planned dates and times for executions, the suffering could make plans to be as close as possible when the deed was done, as it was well known that healing energy began to wane immediately after death.

Much of what we know today about medicinal cannibalism and "the gallows touch" came from newspaper reports of the day. While common sense dictates that a people of English extraction most likely brought English beliefs with them, it is difficult to determine if this was true of Pennsylvania's early Quakers. Scant evidence appears in colonial newspapers to substantiate arguments in either direction. Pennsylvania's early criminal code called for execution for only two crimes—treason and murder—as opposed to the over two hundred crimes punishable by death in England, so actual examples of hanged criminals were much fewer. The resulting lack of executed criminals, paired with fewer early newspapers to report on them, has contributed to an unclear picture of the gallows touch and corpse medicine in early Chester and Delaware Counties.

We do, however, have access to examples of "stroking" in Pennsylvania among settlers of German extraction, though the emphasis was less on the hanged man and more on the ordinary deceased and the objects surrounding their demise. Wayland D. Hand, in his analysis of folk medical curing among the Pennsylvania Germans, cited examples in which the hangman's rope was used for curing "fits" in Pennsylvania, and people suffering headaches could be cured by tying around their head "the halter

Executioner holding a baby to be "stroked" by a dead man's hand. (Mike Sharp)

wherewith a person had been hanged." The rope utilized by someone to commit suicide was thought to treat epileptics. More frequently, early Pennsylvanians would have visited houses where the recently deceased were laid out, or even gone straight to the undertaker's, in order to cure complaints like goiters and wens by rubbing a dead man's hand over the affected area.[19]

All of the preceding serves to show that early Pennsylvanians experienced an intimate and everyday relationship with the supernatural. They could be the victims of perceived magical attack, but they also believed in their ability to proactively defend themselves using "white magic." Due to the colony's Quaker beginnings, the presence of the unknown in their lives seems to have been perceived less as an evil outer force that they must endure, and more as a fact of everyday life for which they had a ready response. This allowed Pennsylvanians a level of agency and control in the supernatural world that other American colonists did not enjoy.

Notes

1 To be fair, Pennsylvania and Delaware (both part of William Penn's original land grant) do have examples of shipwrecks, werewolves and lost colonies, but are outside of the scope of this particular analysis.

2 Anne Somerset, *The Affair of the Poisons: Murder, Infanticide and Satanism at the Court of Louis XIV* (New York: St. Martin's Press, 2003), 310

3 J. William Frost, "Religious Liberty in Early Pennsylvania," *The Pennsylvania Magazine of History and Biography,* Vol. 105, No. 4 (Oct. 1981), 419–451.

4 Ibid., 423.

5 Ibid., 425–426.

6 Ibid., 426.

7 John Fanning Watson, *Annals of Philadelphia and Pennsylvania in the Olden Time; Being a Collection of Memoirs, Anecdotes, and Incidents of the City and its Inhabitants...* (Philadelphia: Published by the Author, 1844), 265.

8 David Hacket Fischer, *Albion's Seed: Four British Folkways in America* (Oxford: Oxford University Press, 1989), 528–529.

9 Ibid., 528.

10 Frank Bruckerl, "The Quaker Cunning Folk: The Astrology, Magic, and Divination of Philip Roman and Sons in Colonial Chester County, Pennsylvania," *Pennsylvania History: A Journal of Mid-Atlantic Studies,* Vol. 80, No. 4 (Autumn 2013), 484.

11 William H. Lloyd, *The Early Courts of Pennsylvania* (Boston: The Boston Book Company, 1910), 67–68.

12 Fischer, 527–528. Although officials failed to act on suspected witches, Pennsylvanians sometimes took matters into their own hands. In 1749 a Philadelphia crowd rioted when the court refused to punish a man accused of wizardry; in the same city in 1787, an old woman was dragged from her house by a mob of young people and stoned to death in the street. Fortune tellers and witch doctors were not unknown amongst the settlers of Germantown, either.

13 M. J. Becker, "An American Witch Bottle," *Archaeology*, Vol.33, No. 2 (March/April 1980), 18–23.

14 Ibid., 20.

15 Owen Davies and Francesca Matteoni, *Executing Magic in the Modern Era: Criminal Bodies and the Gallows in Popular Medicine* (London: Palgrave Macmillan, 2017), 29–52.

16 Richard Sugg, *Mummies, Cannibals, and Vampires: The History of Corpse Medicine from the Renaissance to the Victorians* (Milton Park, UK: Routledge, 2011), 35.

17 Owen Davies and Francesca Matteoni, "'A virtue beyond all medicine': The Hanged Man's Hand, Gallows Tradition and Healing in Eighteenth- and Nineteenth-century England," *Social History of Medicine*, Vol. 28, No. 4, 686–705.

18 Ibid., 686.

19 Wayland D. Hand, "Hangmen, the Gallows, and the Dead Man's Hand in American Folk Medicine," *Medieval Literature and Folklore Studies: Essays in Honor of Francis Lee Utley*, ed. Jerome Mandel and Bruce A. Rosenberg (New Brunswick, NJ: Rutgers University Press, 1970), 323–387.

"Divers Horrid, Complicated Crimes": The Devil in Delaware County

When we think about colonial Pennsylvania, we typically envisage Philadelphia—its quaint cobblestone streets, cozy Georgian townhomes, market stalls with fruits and vegetables, and men in powdered wigs and knee breeches strolling arm-in-arm with women in enormous silk petticoats. Or maybe you imagine those same cobblestone streets, but with harried-looking women dumping overfilled chamber pots into the gutters. Both would be correct, depending on which part of Philadelphia you're imagining. But even in 1720, the population of Philadelphia proper only stretched for roughly eight city blocks, and the farther afield you traveled from the banks of the Delaware River, the more you realized how far outside of civilization you were.

While Concord Township at the turn of the eighteenth century wouldn't quite classify as the "frontier," you probably couldn't convince city dwellers of that. Between 1680 and 1699, the township only had five roads. Even by 1735, when Nathaniel Newlin Jr. began wooing Esther Metcalf of Darby, her horrified parents expressed concerns about their daughter living in the backwoods of Concord "where bears abounded."[1] The residents of Concord Township, though, recognized that their little corner of Pennsylvania had everything it needed to become a center of commerce—plentiful waterways for mills, lush and fertile farmland, timber for building, and a location close enough to Philadelphia to be attractive to incoming immigrants, but far enough away to avoid the stink, filth, and overcrowding typical of a colonial city. It was a natural waystation for wagoners moving goods from the hinterland to the ports

of Philadelphia, Chester, and Wilmington, which meant that travelers of all shapes and sizes might wander through their little village in the near future.

Between 1700 and 1719, leading Concordians initiated a flurry of roadbuilding. Farmers cleared land for wheat (soon to become southeastern Pennsylvania's major cash crop), and enterprising individuals invested in grist and sawmills along the Chester and Brandywine creeks. By 1720, southeastern Pennsylvania was well on its way to becoming a breadbasket of the colonies, but a major obstacle stood in the way—all of this required backbreaking labor, and they just didn't have enough warm bodies to accomplish it.

The labor shortage wasn't from lack of immigration into the area, but from lack of incentive to remain in service to someone else. In the early 1700s land was so cheap and plentiful that most immigrants coming over from Europe could either purchase land outright, or only needed to work a short amount of time before they could afford to buy their own homestead. Without the hands needed to do the work, it didn't matter how much acreage you owned. In the 1680s a prominent Quaker named Rowland Ellis received 700 acres from William Penn that he called "Bryn Mawr," later known as Harriton. By the 1690s, Ellis wrote to a relative that he had only managed to cultivate 15 of his 700 acres, which was barely enough to support his family. It was estimated at the time that a successful farm, providing enough food for family use and for sale, needed to have about 60 acres under cultivation. Add in the extra hands necessary to help in the mills and taverns, and the shortage of labor in the countryside became a critical stumbling block to Concord Township's dream of growth.

The eighteenth-century landowner or businessman had a few options to bolster his workforce. First, he could get married and set about raising a hard-working brood—condemning his wife to a cycle of pregnancy and childbirth that could occupy more than 20 solid years of her life. But even the most exuberant of couples still needed to wait at least six or seven years for their firstborn to be of useful working age. To bridge the gap, the landowner might hire wage laborers who often "came to stay" for set periods of time. Many of these wage laborers were women

(often extended family or near neighbors) who rendered domestic services like spinning, laundering, and butter-making in exchange for pay. Alternatively, the landowner might consider investing in unfree labor. However, while slavery certainly existed in early Pennsylvania, it never gained the traction that it did in other colonies. This had less to do with any ethical qualms than with economic practicality. Wheat grew well and plentifully in the Delaware River Valley, but it only required around 28 days per year of labor. Most early Pennsylvania farmers couldn't justify the year-round expense of keeping and maintaining an enslaved work force when they really only needed labor three or four times per season. The larger and more diversified farms may have had more demand for year-round workers, but that demand paled in comparison to the backbreaking daily toil required by tobacco- and cotton-producing plantations to the south.

The obvious solution for Pennsylvania farmers was the indentured servant. An indentured servant was typically a man, woman, or sometimes entire family, that wished to emigrate to America but did not have the financial wherewithal to pay for their voyage. In this case, the individual could contract with a ship's captain, who would provide passage in return for the permission to "sell" the individual's labor contract once they reached the port. Depending on the skills of the individual, this contract typically lasted from four to seven years. At the end of the contract the individual received a parting gift like land, sets of clothes, or farming tools (as stipulated in the original agreement). For farmers just starting out with small children too young to work, or needing to clear land before planting could begin, investing in an indentured servant for a specified amount of time provided a much-needed labor cushion.

It wasn't just farms that needed a little extra help. Every growing community needed an inn at which drovers and wagoners could stop for an evening, get a good meal, and have a roof over their head. Once Concord Township was connected by road to the bustling ports and markets of Philadelphia, Chester, and Wilmington, John Hannum saw an opportunity. He and his wife Margery had farmed their 100 acres of land since their marriage in 1690. In the 15 years following their wedding, Margery—poor thing—bore at least 12 children. Having a nest of young

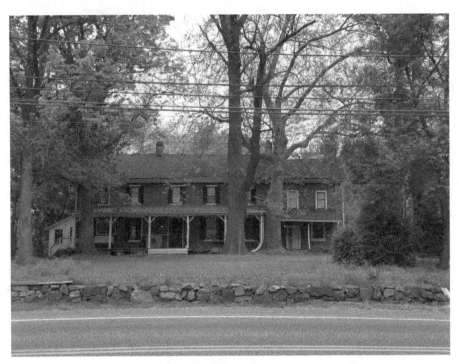

The home of John Hannum in Concord Township. (Author)

children required someone to help with the growing needs of the family and the farm, and in 1696 John bought the services of an indentured boy named Sandy Hunter for five years. The Hannums must have been doing well, because in 1705 John purchased 100 additional acres to the south of his original property, and when the Concord–Chester Road running past his house became a well-traveled thoroughfare, he enlarged his house and turned part of it into an inn.

In 1720, Hannum decided to invest in another servant. We don't know if he needed help on the farm, or in the inn, or possibly a little of both. Most of his children were grown and likely out of the house by this time. We also don't know the process by which Hannum acquired his indentured servants. It was typical in the late seventeenth and early eighteenth century to have some form of pre-existing acquaintanceship between master and servant, either directly or through family or other connections. Contracts were often oral, so few historical records exist

about these early labor relationships. As a result, whether John Hannum knew William Batten before the boy arrived on American soil, or if he had any inkling about the tragic consequences that would follow, remains a mystery. William Batten, to put it lightly, came with some baggage.

William was the son of William and Alice Marten Batten of Whiteparish in Wiltshire, England. Both the Battens and the Martens had deep agricultural roots in Wiltshire that went back several generations, which is notable considering that a number of emigrants to Concord Township and neighboring Bethel Township also came from the Wiltshire area. From an early age William's behavior troubled his parents; he lied compulsively and stole from neighbors, family, and perfect strangers. In his later confession, he claimed that he heard the voice of the Devil, who urged him to misbehave. These petty crimes resulted in him having to abscond from authorities for extended periods of time, leaving his family to make excuses for his behavior. As an adolescent he was imprisoned on multiple occasions for theft. We can conjecture that William's family must have made reparations for his crimes, because he always managed to get out of trouble—that is until 1721, when William was 16, and he found himself on a boat bound for America.[2]

It is unclear how William ended up as an indentured servant. There are three possibilities: first, that he went willingly; second, that he was "spirited" or kidnapped into indentured servitude; and third, that he was sent as punishment for his crimes or in order to avoid more severe retribution in an English court. In his later confession, William stated that, "My Father feeling that there was not any Good like to come of me ordered me to be brought over a Servant into this Province of Pennsylvania."[3] This seems to indicate that it was certainly not William's idea; it also tells us that he wasn't shipped off by the English courts as a convict. It is possible that William agreed in response to pressure from his family, or that his father arranged for him to be "spirited" against his will.

Spiriting was a real and pervasive blight on the whole process of indenture in its early days, made worse by the early lack of contracts and proper record-keeping. A "spirit" typically used force or deceit to trick some unsuspecting victim into indentured servitude. This could include drugging the person or plying them with alcohol to the point

where they were rendered senseless. When they regained their faculties, they found themselves aboard ship and already on the way to the West Indies or to the colonies, without the finances to get back home. In 1671 a spirit named William Haverland turned King's Evidence when he was convicted of kidnapping, and he in turn identified a number of his fellow spirits. One of the men that Haverland incriminated was John Stewart, who had been spiriting for 12 years and had kidnapped an estimated 6,000 victims. Stewart maintained a well-oiled network of accomplices including strong-arm men, dealers in stolen goods, ship's captains, merchants, and corrupt officials on both sides of the Atlantic. Stewart's men (and sometimes women) would find likely victims and sell them to Stewart for 25 shillings, and then Stewart would re-sell them to a ship's captain or merchant for 40 shillings apiece.[4] In a port like Philadelphia, a ship's captain could sell an indentured servant—willing or otherwise—for nine pounds or more depending on the condition and skills of the servant.[5] Every transaction along the line earned the spirits and their accomplices a profit, which made it very attractive, and very difficult to abolish.

Lest you think that kidnapping people and selling them off was a new concept in Britain, you should know that the British government itself had set the precedent that made it acceptable. In 1617, councillors from 100 parishes met at St. Paul's to discuss the overwhelming numbers of poor and orphaned children roaming the streets of London. Their solution was this: the city would pay the Virginia Company five pounds a head to take these vagrant children to Virginia as "apprentices," under the guise that the abductees would be taught a trade and one day granted land. But the agreement with the city allowed the Virginia Company itself to decide the best future for each child, and unsurprisingly most wound up as simple laborers in the tobacco fields. Constables in London were ordered to walk the streets and apprehend vagrant boys and girls, then lock them up at Bridewell Prison until they had enough to fill a ship. Unsurprisingly this work soon had to be conducted with stealth, as Londoners frequently responded to these round-ups of their children "with swords and cudgels." In the spring of 1619, 74 boys and 33 girls were shipped to the Americas for the Virginia Company, which promptly

placed another order for more children to be delivered the following year. These children would experience an intense, if brief, period of suffering—of the 300 children shipped between 1619 and 1622, only 12 were still alive in 1624.[6]

While English law had taken steps to eliminate spiriting by the time William Penn arrived in Pennsylvania in 1682, it did still happen occasionally. A 1725 letter from Edward Busby to the deputy Governor of Pennsylvania claimed that Busby's 14-year-old son had been kidnapped by Captain Sparkes of Bristol and sold to David Evans in Philadelphia for 16 pounds of paper money.[7] It is unknown whether the boy was ever returned to his father.

While most of the victims of spiriting were vulnerable in some way—either transients, orphans, or beggars—they didn't rouse in early Pennsylvanians the amount of resentment that the importation of convicts did. While most convict servants ended up in the southern tobacco colonies, some did land at the port of Philadelphia. Americans got the distinct sense—and they were correct—that England was dumping its unwanted troublemakers on the backwater colonies. A year after William Batten's arrival in the New World, the Pennsylvania Assembly passed a series of laws meant to limit the importation of convicts, including a five-pound duty on each convict servant and a 50-pound bond to be posted by the importer to ensure each servant's good behavior. Crafty transporters, who got kickbacks from the British government, evaded the fees by smuggling criminals into Pennsylvania from other colonies.[8]

While we don't know exactly how William Batten got to Philadelphia, we know from his confession that he lingered at the port—most likely still aboard ship—for "seven or eight days." Batten's experiences in traveling to America were probably similar to those documented by Gottlieb Mittelberger in 1750. In his travel memoir, Mittelberger reported that each indentured servant was permitted a personal space approximately two feet wide and six feet long. He reported the conditions as such:

> There is on board these ships terrible misery, stench, fumes, horror, vomiting, many kinds of sea-sickness, fever, dysentery, headache, heat, constipation, boils, scurvy, cancer, mouth rot, and the like, all of which come from old and sharply

salted food and meat, also from very bad and foul water, so that many die miserably
…. Children from 1 to 7 years rarely survive the voyage.[9]

The long wait of "seven or eight days" seems to indicate that there
wasn't a pre-existing contract or agreement between Batten and
Hannum. When a vessel bearing servants arrived in port, typically
the inmates were kept aboard the filthy and stinking ship while
agents and potential masters surveyed the offerings and negotiated
deals. If Batten was healthy, his age and condition would have made
him a desirable prospect. Either Hannum or an agent acting on his
behalf purchased Batten's indenture and transported him to Concord
Township. Since the indenture documents either never existed or
haven't survived, we don't know the terms or length of the indenture.
By Batten's own account he started lying and running away within
three months, and after one year Hannum sold him to Joseph Pyle
of neighboring Bethel Township.

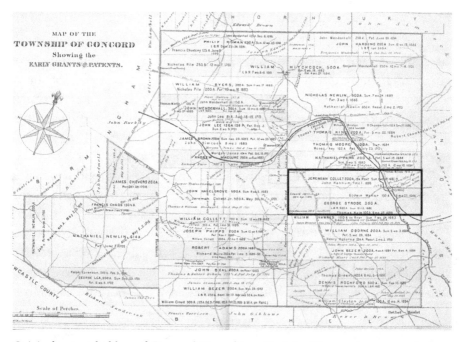

Original patent holders of Concord Township with John Hannum's property in box.
Bethel Township is directly south. (Delaware County Historical Society)

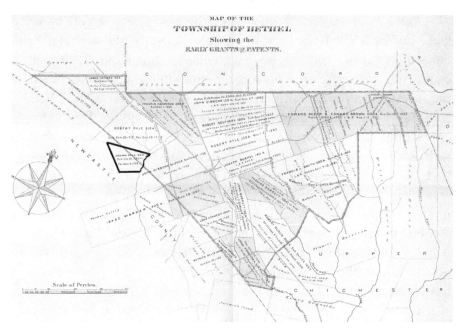

Original patent holders of Bethel Township, with Joseph Pyle's property in box. Concord Township is directly north. (Delaware County Historical Society)

Doubtless Hannum and Pyle knew each other; the Hannums and Pyles were both prominent Quaker families in neighboring townships (though John Hannum left the Friends after 1702). John Hannum's wife Margery grew up on a property adjoining the Pyles, and they also had mutual friends in the Newlin family, who held extensive property in both townships and had married into both the Pyle and Hannum families. What is uncertain is how much Joseph Pyle knew or understood about William's behavior prior to John Hannum selling him. But by 1722, the Hannums of Concord Township had delivered a devil into the Pyle home.

Joseph Pyle was born in 1692 to Robert Pyle and Ann Stovey Pyle in Bethel Township, Delaware County. In 1715, Joseph married Sarah Dix, and they lived on a sizable piece of farmland not far from his father's, straddling the Delaware state line. Not long after, Joseph and Sarah welcomed their first child, Robert, followed by Joseph Jr. in 1718 and finally little Ralph around 1720.

Starting your farming family with three sons was a run of good luck, but by 1722 Robert was still only six years old, and the Pyles needed a stronger back to help with the endless requirements of an eighteenth-century farm. At some point Joseph agreed to purchase the indenture of John Hannum's troublesome servant, William Batten, and the 17-year-old Batten moved into the Pyle house. If Joseph was aware of William's misbehavior, one must wonder why he agreed to take on the challenge, especially with three young children in the house. Did Joseph think he could reform William, either through peaceful or violent means? Abuse of servants was a commonplace occurrence in eighteenth-century America, and there was little legal recourse for servants to make complaint of abusive masters. Or did John Hannum manage to hide the behavior of his troublesome servant in order to offload him without losing his investment? Either way, the choices of both men led the Pyle family into disaster.

After arriving in the Pyle household, William began to hear the voice of the Devil again. On a warm summer night in 1722, Joseph and Sarah left for the evening to visit the home of Nathaniel Newlin, about a mile and a half away. William stayed behind, and about an hour later put the children to bed. After six-year-old Robert and four-year-old Joseph were tucked away in the room they shared, with little two-year-old Ralph in another room, William went up into the attic, using the light of a candle, where the apples and flax were stored to dry. As he gathered apples, he suddenly had the impulse to set the house on fire. He later claimed that it was the voice of the Devil, convincing him that he could burn the house down and everyone would suspect he'd died in the fire, leaving him free to run away. He set the candle to the dried flax and watched the flames spread.

In his confession, William claimed that he had a change of heart and ran downstairs to get water, and when he came back, he was able to douse the flames. Thinking the fire extinguished, he went downstairs and laid down by the hearth, where he fell asleep, only to be awoken by "a great noise like the firing of a gun."[10] When he ran back to the attic to find the source of the noise, the flames had already consumed much of the roof. There was no stopping the conflagration.

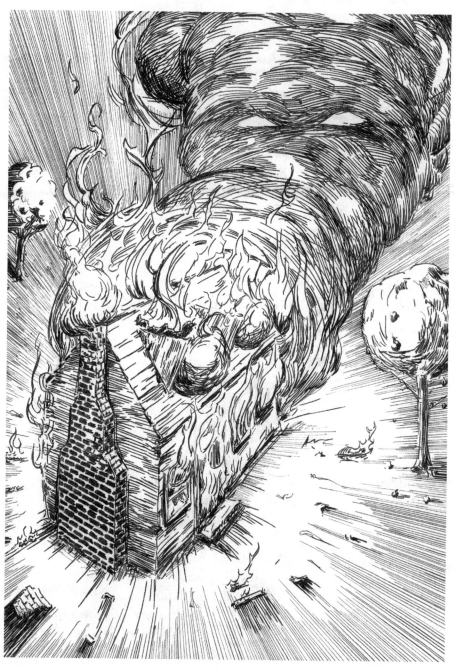

Artist rendering of the Pyle house fire. (Mike Sharp)

He fled the attic, and in running downstairs saw that Ralph had woken. William asked why the boy was awake, and Ralph responded that he wanted his mother. Instead of saving the boy, William gave him a slap and put him back to bed, claiming that the Devil had put it into his mind that he didn't care whether the children lived or died.

At that point, William could have run away. He later argued that he realized he wouldn't have gotten far and would have been recaptured. Going back into the house to save the children did not seem to have occurred to him. Instead, William ran to the Newlins' house and alerted the Pyles of what had happened. When Joseph and Sarah asked where the children were, William lied and told them they had escaped the blaze. The Pyles probably felt a mix of grief for their house and relief that their children were safe. We can only imagine what they experienced when they reached home and realized the truth—their children had died in the fire.

Naturally, suspicion immediately fell upon William. He maintained his innocence all through the later questioning and trial at the courthouse in Chester, and only in the days leading up to his execution did he finally confess to the crime. In the early eighteenth century it was common for a condemned man or woman to put in writing a "penitent confession" which could be read aloud at the hanging and published in the newspaper. This confession was not required for a sentence to be carried out, but—like executions being conducted in public—served as an additional warning for spectators against committing similar crimes.

This didn't mean that the condemned always confessed, or even seemed at all penitent about the state of affairs that brought them to the gallows. Historian Michael Meranze argued that "It was this realm of freedom—to speak or not to speak, to question or not to question—that made the confession such a crucial moment in the ritual.... The speech of the condemned functioned first of all as a means of reinforcing or denying the legitimacy of punishment and, by extension, the state itself."[11] In his confession, William hit all of the expected talking points: he spoke about what had brought his evil behavior about, admitted his guilt, asked God for forgiveness, and

assured the assembled spectators that he'd received a fair trial. Finally, he provided the masterstroke of a great penitent confession—a warning to all children to obey their parents:

> I greatly desire all youth may take Example by me, and have a Care how they disobey their Parents; which if I had not done, I should not have been here this Day, nor brought to this untimely end. I now declare, in the face of the World, my hearty Abhorrence and Detestation of my Sins; and I trust in God, of his Infinite Mercy, through Jesus Christ who died for me, that he will pardon my Transgression. I also crave forgiveness of my Master and Mistress, whom I have greatly injured, by being Instrumental to the Death of their poor Children; and of others whom I have offended.[12]

William was hanged on August 15, 1722—but that's not where his punishment ended. For one of the only times in its history, the court ordered that the body be gibbeted, encasing it in an iron framework and hanging it in public view until it had decayed to the point where it fell apart. While commonplace in England (at least until 1834, when it was abolished), gibbeting or "hanging in chains" was rarer in America. The convict was almost always dead prior to being gibbeted; only one instance of a live gibbeting has been recorded in the colonies, and that was in 1712 in New York when an enslaved man named Robin was convicted of taking part in a conspiracy against his enslaver.[13] In Pennsylvania, the punishment was exceedingly rare; William was one of only three men sentenced to gibbeting, and one of only two where the sentence was thought to have been carried out—Thomas Wilkinson, a convicted pirate, received a stay of execution and no further record exists of the sentence being carried out. The alleged unused gibbet constructed for Wilkinson's execution still exists in the collection of the Philadelphia History Museum.[14]

The most disturbing aspect of this story is that it is almost entirely unmentioned in Delaware County history. The only account we have of the affair is William's confession, printed in the *American Weekly Mercury* on Thursday, August 16, 1722. There are no other existing historical resources to provide any insight—other than the murderer's—on what happened to the Pyle children that day, or what happened to the Hannums, Pyles, and Newlins in the aftermath. We know that Sarah Dix Pyle,

The gibbet iron allegedly made for pirate Thomas Wilkinson, c. 1780. (Philadelphia History Museum at the Atwater Kent © Philadelphia History Museum at the Atwater Kent/Bridgeman Images. Bridgeman Images)

the mother, must have died in the 1730s, but only because Joseph Pyle remarried and went on to have at least eight more children (two of whom were named Robert and Joseph, presumably after their deceased older brothers). Joseph Pyle eventually moved out of Bethel Township and the entire tragic affair seems to have been forgotten.

What provoked William into murdering three innocent children? Although he was known as a liar and a thief, nothing in William's confession indicated a previous history of violent crime. Was it the hopelessness of condemnation to the Pennsylvania frontier that escalated his behavior? Abandonment by his family? Abuse from his masters? Or was it, as William claimed, simply the handiwork of the Devil?

Notes

1 Robert P. Case, and Virginia M. DeNenno, *Concord Township: Progress and Prosperity in the Nineteenth Century* (United States: Concord Township Historical Society, 1998), 36.

2 "The Speech of the Boy Hang'd at Chester," *The American Weekly Mercury*, August 16–August 23, 1722, 98–99.

3 Ibid., 98–99.

4 Don Jordan and Michael Walsh, *White Cargo: The Forgotten History of Britain's White Slaves in America* (New York: New York University Press, 2007), 129.

5 Sharon V. Salinger, *To Serve Well and Faithfully: Labor and Indentured Servants in Pennsylvania 1682–1800* (Bowie, MD: Heritage Books, Inc., 2000), 78.

6 Jordan and Walsh, 78–85.

7 Salinger, 79.

8 Ibid., 78.

9 Jordan and Walsh, 222–223.

10 "The Speech of the Boy Hang'd at Chester," *The American Weekly Mercury*, 99.

11 Michael Meranze, *Laboratories of Virtue: Punishment, Revolution, and Authority in Philadelphia, 1760–1835* (Chapel Hill: University of North Carolina Press, 1996), 37.

12 "The Speech of the Boy Hang'd at Chester," *The American Weekly Mercury*, 99.

13 Thorsten Sellin, "The Philadelphia Gibbet Iron," *The Journal of Criminal Law*, Vol. 46, No. 1 (May–June 1955), 18

14 Ibid., 23.

"An Audacious and Profligate Tory": The Rise and Fall of the Highwayman James Fitzpatrick

Since the first stirrings of European settlement, political and moral conflict have dogged the American Experiment. In hindsight it could not have played out any other way; the New World was always intended to be a place of freedom for many, and the definition of freedom was just as diverse as the backgrounds from which these immigrants escaped. One extreme example was in Massachusetts. The idea of religious liberty for Boston's Puritans meant that *only* their beliefs were allowed, to the extent that they executed four Quakers in 1659–61 for refusing to leave the colony.[1] In Pennsylvania, William Penn's vision for an open and free society, where all were ostensibly welcome, caused its own kind of tension as disparate ethnic groups struggled to live peacefully alongside each other. Penn could not have envisioned the strife that his policies of openness would provoke within a century of his colony's foundation.

Between 1682—when Penn landed on the shores of New Castle, Delaware at the vanguard of ships of immigrants from England and Wales—and 1717, the trickle of arrivals into the new colony was small and, above all, familiar. Most of the newcomers were culturally similar to those who had arrived before them. The summer of 1717, however, brought some travelers to Philadelphia who not only didn't speak English, but also included convicted criminals foisted upon Pennsylvania from an England relieved to see them gone. These new colonists included the Scots-Irish and Germans, and colonial administrators struggled to monitor and stem the tide in those first few years. In the late 1720s, the deluge became utterly uncontrollable. In 1727, 1,000 Scots-Irish arrived,

followed by 3,000 in 1728 and almost 6,000 in 1729. In addition, over 2,000 German-speakers arrived in the same three years.[2]

The first Quaker settlers in the area mistrusted the immigrants for a variety of reasons. First, the Scots-Irish and Germans didn't subscribe to the modesty that Quakers prized. They engaged in behaviors like singing, dancing, gambling, and drinking, and the profanity and lewdness of some of the immigrants shocked and dismayed the Friends. Worse, these Scots-Irish hailed from famously violent areas, and they had developed a reputation among the peace-loving Friends for settling disputes with their fists. These were men and women from the border region between northern England and Scotland, a wild place that until the 1745 Jacobite rebellion hadn't known more than 50 consecutive years of peace in the last 500. The Scots-Irish had, over the centuries, developed their own system of law and order, which sometimes clashed spectacularly with the Quaker one. While the Germans eventually earned the respect of the Quakers by being industrious and hardworking (and above all, abiding the laws established by Penn's heirs), the Scots-Irish fought—in every sense of the word—for representation and recognition.[3] Mix the Scots-Irish with what was possibly the largest population of nonviolent people in North America at the time, and Pennsylvanians were sitting on a political and cultural powder keg.

This was the Pennsylvania into which James Fitzpatrick was born— bubbling with ethnic tensions and on the verge of the greatest political revolution in history. Fitzpatrick grew up in a tenant house on the farm of John Passmore in Doe Run, between Kennett Square and Coatesville. He shared the house with his mother, though the identity of his father is unknown. He started learning the blacksmith trade under Passmore's guidance, and grew into a tall, muscular, and handsome young man.[4] He was later described as having a body like Hercules and a face like Apollo, with sandy red hair and a charming and gregarious nature.

Fitzpatrick was in his late twenties when the Revolutionary War broke out; like many of his Scots-Irish neighbors he was a strong supporter of the rebellion and immediately volunteered for Pennsylvania's militia. By the summer of 1776, his militia unit were in Long Island to assist Washington's army. By some accounts he sustained a minor wound in

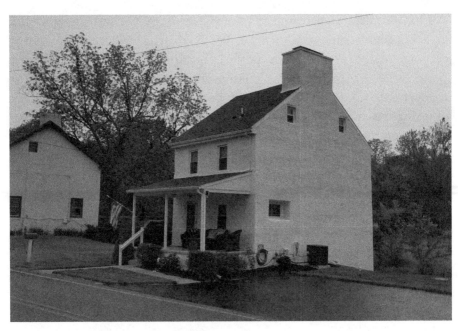

The tenant house on the property of John Passmore in Doe Run, alleged to have been the childhood home of James Fitzpatrick. (Author)

action, and when asked to conduct some menial task before he was fully healed, he refused. His punishment was flogging; he was so incensed by the humiliating treatment—he was a *volunteer*, after all—that he deserted, swimming across the Hudson River and heading back toward Chester County. He made it as far as Philadelphia before he was recognized and imprisoned in the Walnut Street jail; he was released after he promised to rejoin the army, which was hemorrhaging soldiers due to desertion. Instead of following through on his promise, he made his way back to Passmore's farm, where in the summer of 1777 a militia discovered him working in the fields and apprehended him again. He agreed to go with them but asked that he be allowed to say goodbye to his mother and pack some belongings first. Instead of bidding farewell to his family, he grabbed a rifle and threatened to shoot his captors if they didn't leave him alone. This threat apparently worked; they retreated and by September 1777 Fitzpatrick had switched sides and was serving as a guide for the British at the battle of Brandywine.

The complete turnaround from avid patriot in 1776 to angry loyalist in 1777 might come as a surprise, but Fitzpatrick was a man of strong passions, and he lived in the perfect location for such an about-face. There were few places in the colony where a loyalist could find more support than Chester County. Forty percent of the county was Quaker, who for the most part were avowed pacifists who would not support the war effort in any way, either by fighting or by paying taxes. A large percentage of the rest of the county were active loyalists, small farmers and artisans who secretly—or not so secretly—aided the British and harassed their patriot neighbors. The prospects for recruiting for the American armies in Chester County was so dismal that a disgusted General Anthony Wayne suggested that he stop recruiting there altogether and shift his focus to more successful efforts in Berks, Lancaster, and York counties. The strongest center of support for the rebel cause was actually among Fitzpatrick's own people—the Scots-Irish—but he soon found he was able to travel quite freely around Chester County and find support and comfort from loyalists.[5]

After the battle of Brandywine on September 11, 1777, Fitzpatrick embarked on a short but dazzling career as a highwayman and general thorn in the side of the patriot cause. His main targets were tax collectors, which also seemed to bolster his reputation in the eyes of even non-loyalist factions. Tax collectors were roundly hated in Chester County by all walks of life, which should come as no surprise to a reader familiar with a little act of tax defiance called the Boston Tea Party. After the Revolution, Pennsylvanians expressed their disdain for taxation even more eloquently with the Whiskey Rebellion (1794) and the Fries Rebellion (1799).[6] In addition to collecting taxes, constables in early Pennsylvania were responsible for a dizzying array of tasks: attending the courts, serving warrants, apprehending indicted persons, assessing property or seizing it for debts owed, and maintaining the peace were just a few. They were expected to report on the number of bonded servants, "baseborn children," illegal stills, deer killed out of season, and women suffering from "the rising of their apron."[7] Essentially, they were expected to rat out their neighbors, who in many instances responded poorly to the perceived betrayal. In 1697, a Chester County constable investigated reports of a woman who

had given birth and then murdered the child, only to be met at the door by the knife-wielding woman and her equally armed brothers and sisters. In 1789, a man named George Varner owed a debt of about £2 and when constable William Griffith tried to seize his cow as payment, Varner rounded up two friends and all three men attacked the constable and took the cow back. When Sheriff John Owen tried to arrest Charley Hickinbotom, the lady of the house threw scalding hot broth at him and struck him with a stone.[8] Unsurprisingly, few men were keen to fill official positions like sheriff and constable—when nominated, many tried to wriggle out of it by claiming hardship, sending substitutes to serve in their place, or simply skipping town. Refusal to serve meant a fine to pay, which likely was the less egregious of the two options presented to the eighteenth-century Pennsylvanian.

James Fitzpatrick delivered his share of physical punishment to Chester County's constables and militia recruiters, but one fact bears remembering—there is no historical evidence that Fitzpatrick ever killed anyone. In a tip of his hat to the flogging he received at the hands of the American army, his favorite method of punishment came at the end of a whip, preferably accompanied by a healthy dose of humiliation. The extent to which he toyed with patriots seems unbelievably reckless to modern readers. In one instance, he visited the Unicorn Tavern in Kennett Square, which was famous for being a center of patriot activity (and was later burned down by loyalists) and ordered a drink at the bar. A crowd filled the tavern, getting inebriated and bragging about what they would do to Fitzpatrick if they were ever to catch him. Fitzpatrick stayed at the bar quaffing his drink until he was recognized, at which point he backed out of the tavern, keeping the shocked gaggle at bay with his pistol, and then escaped into the woods. On another occasion, Fitzpatrick joined a couple of tax collectors who were walking down a country road and engaged them in conversation. When they boasted that they were not afraid of "the Fitz," and that *they* wouldn't let him escape, Fitzpatrick suddenly turned around, disarmed them of their muskets, and robbed them. He then tied the two collectors to a tree and flogged them. Knowing that one of them, Captain McGowan, was especially proud of his long hair, he relieved the man of his sword, his pistols, his

watch—and his ponytail. When McGowan protested that the watch was a family heirloom, though, Fitzpatrick gallantly returned it.[9]

Fitzpatrick demonstrated his unusual sense of honor again when he encountered an elderly woman in East Caln taking a basket of eggs to market. He initially robbed her of the eggs, but when the old woman told him she was poor and needed to sell them, he gave them back. In another instance, when his horse threw a shoe, he stopped at a blacksmith shop in Newtown Square and found it manned by an apprentice named Shillingford. When Shillingford offered to craft a new horseshoe, Fitzpatrick turned him down, saying he would do it himself. As he worked, Fitzpatrick mentioned that a certain highwayman was reported to be in the area, to which the young man responded that he had never met the Fitz but had heard him described. Fitzpatrick then asked Shillingford if he looked like the outlaw, to which the boy replied, "I don't know that you do." At that, Fitzpatrick told the young man who he was, tossed him a coin to pay for the shoe, and left. Later, at the time of his hanging, Fitzpatrick reportedly recognized Shillingford in the crowd gathered around the gallows and shook his hand with a hearty "How are you, brother Chip?"[10]

Fitzpatrick's career burned hot, and therefore it surprised no one—including him—that it flamed out so spectacularly. Since the battle of Brandywine in the fall of 1777, the British had occupied Philadelphia and dominated the surrounding counties, giving Fitzpatrick even more liberty to harass and rob local patriots because he knew the dominant political power would look kindly on his activities. When the British retreated in the summer of 1778, though, Fitzpatrick had to make a choice—go with the British army or stay in Chester County. He elected to stay, and along with a childhood friend named Mordecai Dougherty began committing robberies along the Lancaster Road, which originally connected Philadelphia with Lancaster. Two years of banditry had brought him full circle.

On August 23, 1778, Fitzpatrick showed up at the front door of the McAfee home in Newtown Square, almost directly across the street from one of his reported hideouts in Castle Rock. Modern historians can only conjecture what inspired Fitzpatrick to attack a home so near to the place where literally everyone knew him to hang out, but as we've

shown, Fitzpatrick already possessed a reputation for almost suicidal recklessness. An additional boon to the crime was that Robert McAfee was a militia captain, one of Fitzpatrick's favorite targets. McAfee was taking tea with his elderly parents and a hired girl named Rachel Walker when Fitzpatrick stormed in with rifle, sword, and pistols at the ready. He demanded McAfee's watch and the buckles from his shoes and clothing, whereupon McAfee reported the following:

> [H]e order[ed] my father and mother (both old and infirm) and a girl belonging to the house, who had just then entered the room, all before him up stairs to a bedchamber, where I told him my money lay. Upon entering the room and arranging his prisoners (as he thought safe) he set one foot on the side of a bed to adjust something amiss about his shoe with one hand, and held a pistol in the other directed to me; upon which I cast a look to the girl, signifying I was going to attack, and immediately sprung at him, secured the pistol, and a scuffle ensued, which lasted some minutes before I could bring him to the floor.[11]

If Fitzpatrick was hard to catch, he proved even harder to keep. After the McAfees tied him up and sent for the local militia, he managed to

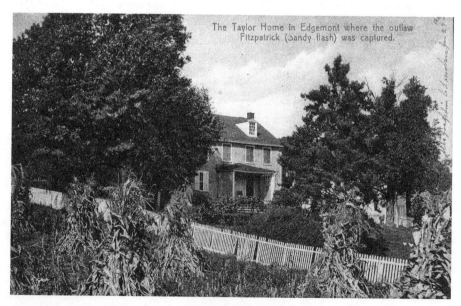

A popular postcard of the Taylor/McAfee home where James Fitzpatrick was allegedly captured. The home has since been demolished. (Keith Lockhart)

loosen the ropes and nearly made his escape. Later at the jail in Chester he almost succeeded in filing off his irons. Moved to the Walnut Street Jail (from which he'd already escaped once two years prior) he accomplished the unlikely feat of filing off his handcuffs twice in one night. How he managed this series of near escapes is unknown, though he benefitted from strong support throughout the county. All of McAfee's neighbors, for instance, were Tories sympathetic to Fitzpatrick's cause. It was even rumored that McAfee's own sister was the one who had loosened Fitzpatrick's ropes.[12]

Whether Fitzpatrick had much of a trial is unclear, though it's hard to exaggerate the complete shambles that was the Chester County legal system in 1778. When the Revolution began in May 1776, Pennsylvania's rebels quickly moved to eradicate Tory influence in government. On June 3, 1776, the Philadelphia Committee of Inspection and Observation demanded that the justices of the quarter sessions of Philadelphia cease all operations of the courts until their new government could be instituted. Many officials of the pre-Revolution government resigned rather than try to reason with or work within the radical new leadership. The Committee took until September 1776 to publish its new frame of government, but the resignations of so many public officials and the refusal of many attorneys to work in the courts left a vacuum in the legal system. The ups and downs of drafting new laws and a new constitution left many Pennsylvanians either confused—or disgusted—by what the rebels devised. James Allen, the son of the former Chief Justice William Allen, complained that "not one of the Laws of the Assembly are regarded ... No courts open ... [and] no justice [is] administered."[13] No courts were actually held in Chester county from May 1776 to August 1777, and then were suppressed again during the British occupation from September 1777 until the summer of 1778 when the British left Philadelphia.[14] The courts didn't resume business in a somewhat normal fashion until August 1778—the month James Fitzpatrick was captured.

After a year of British occupation, Chester County's patriot leaders were more than ready to start punishing those who had made that occupation possible. The fall of 1778 witnessed six hangings for "desertion to the enemy" or treason. On November 4, 1778, six weeks after James

Fitzpatrick met his end, two men went to the gallows in Philadelphia for "aiding the enemy." One was John Roberts, a miller from Lower Merion, and the other was Abraham Carlisle, a house carpenter, who were both accused of having enlisted with, or otherwise assisted, the British military. Both men were Friends, and their arrests sent shockwaves through the Tory and Quaker populations around Philadelphia and ignited a very real worry that the reinstatement of American control would mean a bloodbath for suspected loyalists. Twelve men of the grand jury and ten of the petit jury pleaded for mercy, and 387 Philadelphians presented evidence that Carlisle had actually interceded on behalf of prisoners and protected them from cruelty on the part of the British.[15] The Supreme Council was unmoved; the two men were hanged, and their property seized, against a backdrop of accusations of bloodthirstiness.

The legal system that James Fitzpatrick entered in August 1778 was fractured, vengeful, and explosive. Worse for him, there was no doubt whatsoever that he was guilty of his crimes—he had boasted and toyed with authorities for years and openly assisted the British at the battle of Brandywine. However, officials charged him not with treason, but with larceny and robbery. Perhaps they felt that a charge of "treason" in an already fractious Pennsylvania might cause too many arguments about what constituted treason in a county that had been under the control of the British. They wanted Fitzpatrick to swing, so they chose two charges for which there could be no argument. Fitzpatrick confessed to the crimes, and on September 15, 1777 the court sentenced him to be hanged, a sentence that would be carried out on September 26, 1777. It was during this interim that his three spectacular escape attempts—one from the county jail and twice in one night from the Walnut Street Jail—occurred. These escape attempts likely did not endear him to his captors, which makes what happened next a little more suspicious.

In 1778, most executions were public events, and could draw many thousands of spectators. We know that the young blacksmith Shillingford was in the crowd the day that Fitzpatrick hanged. There were no gallows with a trap door; criminals sentenced to hang were subject to what was then called "swinging off," which meant that the accused would stand on a chair, a ladder, or in a wagon, which would then be drawn from beneath

them, causing them to slowly suffocate to death. But when Fitzpatrick was swung off, his incredible height left his toes touching the ground, and he was able to ease the pressure on his neck. The executioner had to jump onto Fitzpatrick's back to force the man's heels down and in fact strangled him to death while Fitzpatrick's feet were actually touching the ground. Whether the executioner accidentally used a rope that was too long, or whether some intentional vengeance was involved, we may never know.

Certainly, botched executions weren't a novel concept in 1778, and they would continue to provide support for abolishing the death penalty throughout the nineteenth century. The hemp ropes used to hang men and women in the eighteenth and nineteenth centuries were generally supposed to be new, but this didn't prevent them from occasionally breaking. At the hanging of William Seeley Hopkins in Centre County in 1890 the rope broke not once, but twice. In 1802, a condemned man named Dan Byers experienced his hanging rope break and then had to wait while a second noose was strung up. On May 15, 1867, the execution of Robert Fogler in Washington County was horrifically blundered in a similar way, when his toes touched the ground. In this instance, several men mounted the scaffold and took the rope into their hands and "actually held the quivering lump of flesh suspended some one foot from the ground while the sheriff and his deputies prepared the tackle to run it up again. For several minutes the body underwent severe contortions and death was far from being an easy one."[16]

In the aftermath of Fitzpatrick's bungled hanging, those involved with his capture experienced their own highs and lows. Fitzpatrick's sympathizers burned the McAfees' stacks of oats and hay and maimed their horses. Later, William McAfee (Robert's father) claimed these losses as part of the British and loyalist predation of the area and was compensated. At the time of Fitzpatrick's capture there had been a £1,000 reward, which Robert McAfee and Rachel Walker split. After splitting the reward, they each walked away with the modern-day equivalent of about $60,000.

With such salacious and romantic facts to work with, it didn't take long for journalists and novelists to broadcast his story as far and wide as

the burgeoning newspaper industry allowed. In a rabidly patriotic new Republic eager for stories of war heroes, Fitzpatrick's image received a makeover. The Robin Hood–esque aspects of his career moved front and center, and his good looks and charm grew as his quick temper and brutality were set aside. His true transformation wouldn't happen until 1866, when Chester County novelist Bayard Taylor used him as inspiration for the highwayman Sandy Flash in *The Story of Kennett*, published in 1866. Taylor was born in Kennett Square, and many of the folktales of his childhood made their way into his novels. Taylor had already earned some success as a journalist and writer of travel books; his friends had last names like Whittier and Longfellow. In 1861, he turned his attention to fiction, and had two popular novels under his belt when he began *The Story of Kennett*, a pastoral ode to his childhood home. In the novel, hero Gilbert Potter struggles with the uncertainty of his parentage, which is keeping him from winning the hand of his true love, Martha, who is of a higher social station than he. When the notorious Sandy Flash robs the townspeople in the local tavern, Gilbert is present and is told by the highwayman that he had nothing to fear, which instills a suspicion in Gilbert that Sandy Flash may be his father. Meanwhile, it turns out that the town's hard-drinking Deb Smith is Sandy Flash's mistress, and in revenge for a slight against her, she betrays him to the authorities. Before he dies, Sandy Flash gives Gilbert the location of some stolen money and admits that he's not Gilbert's father.[17] Taylor's version of James Fitzpatrick was so popular and convincing that a new mythos developed around the criminal. The very nickname "Sandy Flash" gradually overtook the man's real name in popularity—there currently exist two roads in southeastern Pennsylvania named after "Sandy Flash." *The Story of Kennett* reinforced the already popular idea that Fitzpatrick hid a treasure somewhere in Chester County, and that he was romantically betrayed by a lover rather than being foiled by his own carelessness during an act of robbery.

As the twentieth century rolled around, the newly minted Sandy Flash appeared in 1922 in a novel called *Sandy Flash: The Highwayman of Castle Rock* by Captain Clifton Lisle, wherein the author connected Fitzpatrick with the infamous Doan Gang, which spied for the British and robbed the county treasury in 1781. The Doan connection is another bit

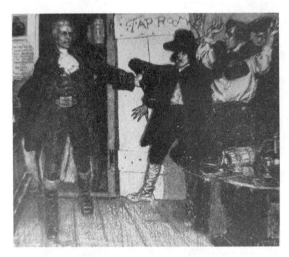

Illustration from Sandy Flash: *The Highwayman of Castle Rock* (1922) by Captain Clifton Lisle, presumably recreating Fitzpatrick's episode in the Unicorn Tavern in Kennett Square. (Author)

of fictional embroidery to the Fitzpatrick tale— although they operated around the same time and area, there is no evidence to suggest they ever worked together. Another legendary Chester County figure, "Indian" Hannah Freeman, also makes an appearance in the novel as a healer with her famous herb salve. Hannah Freeman was thought to be the last member of the Lenni Lenape Tribe in Chester County when she died in 1802.[18] Eleven years after the publication of *The Highwayman of Castle Rock*, Bayard Taylor's novel *The Story of Kennett* was adapted into a pageant for a welcoming audience in Kennett Square, and the legend continues to outpace the man.

Notes

1 The Massachusetts legislature passed a law in 1658 that any Quaker living within the colony would be subject to imprisonment and banishment. Any Quaker refusing to leave the colony, or returning to the colony after banishment, was sentenced to death. This resulted in the hanging deaths of the "Boston martyrs" Mary Dyer, Marmaduke Stephenson, William Robinson and William Leddra.

2 Marietta, *Troubled Experiment*, 64.

3 Marietta, *Troubled Experiment*, 69.

4 Rosemary S. Warden, "'The Infamous Fitch': The Tory Bandit, James Fitzpatrick of Chester County," *Pennsylvania History*, Vol. 62, No. 3 (July 1995), 376.

5 Ibid., 380.

6 The Whiskey Rebellion was a three-year uprising against the tax on all distilled spirits imposed by the federal government to pay off debts incurred during the Revolutionary War. The Fries Rebellion, fomented by an itinerant Pennsylvania

auctioneer named John Fries, erupted over a federal tax on dwelling houses and land.

7 Marietta, *Troubled Experiment,* 129.

8 Ibid., 129–130.

9 Warden, 378.

10 Ibid., 381.

11 Ibid., 384.

12 Ibid., 384.

13 Marietta, *Troubled Experiment,* 181.

14 Ibid., 181.

15 Dr. Negley K. Teeters, *Scaffold and Chair: A Compilation of Their Use in Pennsylvania 1682–1962* (Philadelphia: The Philadelphia Prison Society, 1963), 19.

16 Ibid., 23.

17 Bayard Taylor, *The Story of Kennett,* ed. C. W. La Salle II (New Haven: College & University Press, 1973), 280–281.

18 Capt. Clifton Lisle, *Sandy Flash: The Highwayman of Castle Rock* (New York: Harcourt, Brace and Company, 1922).

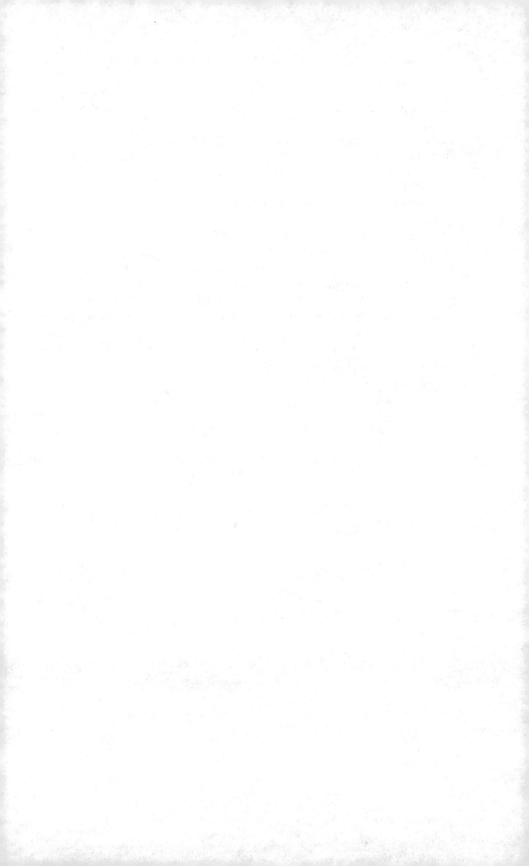

"What Heart So Hard, as Not to Melt at Human Woe!" The Hanging of Elizabeth Wilson

One of the most oft-told tales in southeastern Pennsylvania history is that of Elizabeth Wilson, who met a controversial end at the gallows in 1786. Convicted in 1785 of murdering her twin infants, she gave a last-minute confession that the father of her children committed the crime. Her eleventh-hour revelation spurred a race against time for her brother to acquire a stay of execution and evidence that might exonerate her—tragically coming minutes too late to save her. Her hanging and the subsequent furor over her guilt or innocence resulted in the effective abolishment of executions for infanticide in Pennsylvania. Her story provides all of the necessary ingredients for an A-list Hollywood tragedy: innocence, unrequited love, murder, and a cliffhanger attempt at rescue, made all the more grotesquely romantic by dint of the near miss at salvation. You couldn't write a more suspenseful and heart-rending tale.

But true, it is not. At least not entirely. Like all great melodramas, the facts have been embroidered over time to suit the sentiments of a changing—and changeable—public. Softening the facts does a disservice not just to the modern reader, but to Elizabeth Wilson herself, whose story was shaped and manipulated over time until she became barely recognizable. Historian Meredith Tufts tackled the mythology of Elizabeth Wilson head-on with her 2007 journal article "A Matter of Context: Elizabeth Wilson Revisited," which revealed the cracks in the facade of Elizabeth's glamorized history. Tufts argued that not only was Elizabeth *not* the tragic hero of her own story, but she was probably the villain.[1]

Let's start with the known facts. Elizabeth Wilson was born in 1758 to poor Quakers John and Elizabeth Wilson in East Marlborough Township, Chester County. According to her later confession they were "honest, sober parents" although historical records seem to paint a slightly different picture. In 1743, a complaint was lodged about John Wilson "drinking strong liquor to excess," and a similar offense occurred three years later. After four months of counseling by fellow Quakers failed to improve the situation, the New Garden Monthly Meeting disowned him. John's disownment did not affect the status of his wife and children, of which there were four—John Jr., William, Ephraim, and Elizabeth. The Wilsons led a hardscrabble existence made all the harder by their father's drinking. There would be no land for the sons to inherit, and no dowry for Elizabeth. Without a dowry, Elizabeth's prospects were dismal.[2]

In 1775 Elizabeth requested removal from New Garden Monthly Meeting to nearby Bradford Monthly Meeting in East Bradford Township, Chester County. At 17 years of age, with her mother likely dead by this time and her older brothers out of the house, we cannot be sure what precipitated the move, but it would have an impact on her later life. It was in East Bradford that she met Josiah Wilkinson, presumably to work for him as a domestic laborer. Just eight months later she was back in East Marlborough and was a witness at her brother Ephraim's marriage in October 1776 (Ephraim was the only one of the four children who would get married and continue life within the Quaker fold).[3]

By 1779, life had begun to disintegrate for Elizabeth. At age 21, Elizabeth gave birth to the first of her four illegitimate children. The New Garden Women's Monthly Meeting reported on 2nd Day, 1st Month that she "hath so far given way to Temptation as to be guilty of Fornication, which is Manifest by her bearing a Bastard Child." Four members of the meeting were assigned to counsel her, but their attempts were half-hearted. Elizabeth's family was notorious in New Garden, and Elizabeth found herself disowned after only three months. Tellingly, she declined to appeal the disownment. Meredith Tufts posits that Elizabeth may not have protested her disownment because she might have felt that she'd done nothing wrong.[4]

There is certainly some evidence to support such an idea. Contrary to popular belief, bearing a bastard child in late-eighteenth-century Pennsylvania was not necessarily the pearl-clutching scenario we tend to envisage through twenty-first-century glasses. Based on records kept by Philadelphia's Overseers of the Poor from 1767–76, approximately one in every 38 adults was parent to an illegitimate child, and sexual relations outside of marriage were fairly commonplace.[5] This liberal outlook did not predominate in every locale, though—Chester County appears to have prosecuted more cases of fornication than many surrounding counties. Prosecution does not, however, reflect actual occurrences, just the stringency with which county officials addressed the problem.[6] Elizabeth's own outlook on life might have been at odds with her more conservative community. In any case, if Elizabeth's marriage prospects among the Quakers was dubious before, they were made negligible after bearing a child out of wedlock. If she had a hope of getting married and securing her future, it would have to be outside of the Quaker fold, in a place where her family's reputation wouldn't pre-determine how she herself would be viewed. Elizabeth decided to make her fortune in Philadelphia.

As the second largest city in the British Empire, Philadelphia offered a cosmopolitan alternative to staid Chester County. By the post-Revolution era, the Quaker disdain for gaudiness and entertainment had lost influence, and Philadelphians in the last quarter of the eighteenth century enjoyed music, theater, literature, sports—and even boasted a celebrated trade in "women of ill fame." Prostitution played a central role in Philadelphia's development as early as the 1760s—which we know because it was a popular topic of the city's broadsides, pamphlets, and plays. Where some cities had red light districts where prostitution could be contained, Philadelphia's brothels seemingly set up shop wherever they pleased. Bawdyhouses existed in Society Hill, on Front Street in Southwark, on High Street near the city center, and in Northern Liberties at the British Barracks.[7] There was even a brothel located near the home of esteemed diarist and prominent Quaker Elizabeth Drinker on Fourth Street.

Despite starring in almanac tales, songs, theater shows, plays, and broadsides throughout the 1760s and 1770s, women were rarely arrested

for prostitution. According to historian Clare Lyons, only three women were prosecuted for prostitution from 1759 until the Revolution, and all three for operating a bawdyhouse (not for simply working in one). At the same time crimes against property, like burglary and robbery, frequently appeared in reports. Clearly Philadelphians paid little attention to prostitution in their city as long as it didn't lead to other, more serious crimes.[8]

This was the world in which Elizabeth found herself after 1779. While sex work paid well and allowed the most freedom for women in eighteenth-century Philadelphia, there is no evidence that Elizabeth ever plied the sex trade. The most popular work for unmarried women at the time was in domestic service, though the hours were long, the pay low, and the future outlook uncertain. Elizabeth found a job at the Cross Keys Inn at Third and Chestnut Streets, which—given its location so near to the city's rowdy docks—was likely not the most genteel of establishments. Taverns that catered to the laboring classes quickly developed a reputation for raucousness and the unseemly allowance of men and women to socialize *together*. Such places tended to relax its guests' ethical and moral restraints, and likely encouraged sexual abuse against patrons and servers. Whether consensual or a result of sexual abuse, Elizabeth became pregnant again in 1783. The fates of her firstborn child and the one that followed are unknown, but in 1784 she conceived again—this time with twins, which was much harder to hide than a single pregnancy. Even in a disorderly house like the Cross Keys Inn, an obviously pregnant server was embarrassing, and she was asked to leave. With little money and few contacts in the city on which she could depend, Elizabeth found shelter at the home of her old employer, Josiah Wilkinson of East Bradford. On October 1, 1784, she gave birth to twin daughters.

Elizabeth only stayed with Wilkinson for about two months. Four weeks after the birth she went to Philadelphia for a brief visit, leaving the twins at home, and at the end of November she announced to Wilkinson that she was returning to the city permanently. She left with her babies and her belongings and was spotted a short time later suckling her infants by the side of the road.

Elizabeth made it to Philadelphia—but her babies did not. In late December, their small, naked, mangled bodies were found in a grove not far from Wilkinson's home, laying in a shallow depression and covered over with leaves. Elizabeth was found in Philadelphia and arrested on suspicion of having committed the murder of her children. At her arraignment she claimed that she had abandoned her children by the side of the road in the hope that someone would take care of them but protested that she had not killed them.

Elizabeth wallowed in jail for six months before she was indicted for murder and sentenced to stand trial in October 1785. During that time, she maintained that she had abandoned her infants but that she was innocent of murder, and said very little else. She refused to waver from her given story, even when prompted by visiting clergymen on several occasions.

Elizabeth's trial began in October, ten months after her infants were found dead, and the same month in which the unfortunate children had been born one year earlier. The 12-man jury was overwhelmingly Quaker, including four men from her meetings in New Garden and East Bradford who would have known her, or at least been familiar with her and her family. Others either owned property in neighboring townships or were connected by blood or marriage to Elizabeth. As a result, the jury was far from unbiased. They would have been well aware of the drunkenness of her father and her own past indiscretions, including one bastard child born in Chester County and another born in Philadelphia. Furthermore, because Pennsylvania law allowed for legal representation but did not provide it, Elizabeth faced this jury and trial officials alone. She could not afford a lawyer to represent her. Not even her father or brothers appeared in her defense, though they all presumably still lived in Chester County at the time. In his autobiography, Charles Biddle stated that not only was her brother William aware of the charges against her, but that he fully believed she was guilty of killing her babies.[9]

Elizabeth had other hurdles to overcome, for which a lawyer might have come in handy. The laws regarding infanticide in Pennsylvania at the time were an almost impossible tangle for any woman to escape,

all of which stemmed from a decree called the "Concealment Statute." The law basically argued that the repercussions of having a child out of wedlock were so terrible that an unmarried woman who found herself pregnant would naturally wish to conceal the pregnancy and dispose of the resulting child before anyone could discover her transgression. Prosecution under the Concealment Statute only required that the court prove four circumstances: that the dead child belonged to that mother; that it was illegitimate; that it had died; and that the mother had attempted to conceal the death. To refute any of those charges, the woman needed to provide witnesses. If she could not, she was considered guilty until proven innocent.

The relative ease of conviction under the Concealment Statute was often balanced by the fact that most jurists found the law to be unfair at the outset and tended to exhibit leniency with regard to conviction. A woman who was open about her pregnancy, prepared for the birth of her child, or enlisted help in the birthing process could evade the charge of concealment, even if her child died. In addition to Elizabeth, the years between 1768 and 1785 witnessed 21 women charged under the Concealment Statute—but only four were convicted.[10] So though it seemed the odds were stacked against her, Elizabeth had good reason to hope that the jury would take pity on her.

Elizabeth had some evidence in her favor. Josiah Wilkinson and his son John testified that Elizabeth had given birth at their home, thus she had not attempted to hide the delivery. Another witness testified to driving Elizabeth in his wagon toward Philadelphia and leaving her by the side of the road to nurse her children—thus demonstrating that she had cared for their needs. She had obviously provided food and clothing for her babies, which was often evidence enough in the hands of a sympathetic jury to overturn the Concealment Statute.

All of the positive evidence of Elizabeth's love for her children was, however, counterbalanced by the state in which they were found. The witnesses who discovered the bodies testified that they had been found unclothed and "brutalized." While animals might have done the mauling, the fact that they were unclothed indicated an intent to expose them to the elements—a distinctly unmotherly and murderous act. To save her

own life, Elizabeth would have to persuade the jury of her maternal love or produce witnesses that could testify that the infants died of natural causes.[11] Since she herself testified that she had left them by the road, she would have no way to produce a witness to testify how they died. She also had an uphill battle to fight with jurors who were already predisposed to disapprove of her and her behavior. The jury not only believed her capable of committing murder, but of killing her own children in a particularly cruel and grotesque way. She was convicted and sentenced to hang by the neck.

Elizabeth still had one remaining hope that the Supreme Executive Council, which had to issue the death warrant, might grant her clemency. Of the four women found guilty under the Concealment Statue, the Supreme Executive Council had pardoned two of them. The Council sat on Elizabeth's trial transcript for a month, while she wrote three different statements begging for forgiveness and leniency. The Council finally—and probably to the surprise of many—issued a death warrant for Elizabeth's execution for December 7, 1785.[12] For those that found the Concealment Statue unfair, or believed even a morsel of Elizabeth's testimony, this decision to uphold her execution was truly shocking.

It was on the day before her scheduled execution that Elizabeth's brother William finally visited her, and she "confessed" to an entirely different course of events. She told William that her lover had actually killed the children. Armed with this new information, William rode to Philadelphia to seek a stay of execution. That night, Elizabeth dictated her final confession, in which she claims a man named Joseph Deshong seduced her with promises of marriage and abandoned her when she told him she was pregnant. With nowhere else to go, and apparently such a fraught relationship with her father that she was either unwilling or unable to return to his house, she sought refuge with Wilkinson for whom she had worked years before.

That brief trip back to the city after the birth of her twins was to seek Deshong out; she asked him for child support and threatened to take him to court if he refused. The courts in Philadelphia were very sympathetic toward unmarried women seeking financial support

from the fathers of their children. In Philadelphia, an agency called the Overseers of the Poor assisted those in need, including abandoned wives, unmarried mothers, and bastard children. The Overseers took responsibility for regulating child support, thus ensuring that women did not have to bear the burdens of sexual misbehavior alone, and that the onus of child support only fell upon the community at large if the father did not have the financial wherewithal. Even in Chester County, where Elizabeth had borne her children, courts after the Revolution were more interested in pursuing the men accused of fathering bastard children than in charging the women with fornication. The central concern seemed to be keeping these women and children off of the public dole.[13] Deshong would have been well aware that the law was on Elizabeth's side in this matter, and it was highly unlikely he would escape without his reputation–and finances—being dragged along for the ride.

According to her second confession, Deshong responded to Elizabeth's threat by promising to give her money if she kept his name out of the courts and he agreed to meet up with her at a later date to deliver the funds. One presumes that this was the day that Elizabeth told Wilkinson she was returning to Philadelphia permanently. Elizabeth claimed that Deshong intercepted her on the road before the arranged meeting point, dismounted, and convinced her to walk with him in a nearby field. When they entered a grove of trees, Deshong and Elizabeth sat down on a log and Deshong took the infants from her, placing them on the ground. He asked what she planned to do for them; she replied that it was his responsibility to "do for them."[14]

Elizabeth claimed that Deshong took a pistol from his belt, leveled it at her chest, and ordered her to kill the babies. She refused—at which point Deshong then stomped the children to death and directed her to remove their clothing, which she did out of fear. He then scraped a shallow hole in the ground, placed the babies inside with a token covering of dirt, and ordered her to never reveal what he'd done.

On the merits of this story, William was able to negotiate a stay of execution for his sister until January 3, 1786, which gave him 30 days to collect new evidence that would support Elizabeth's story. Over the

next few weeks, he managed to discover that Elizabeth's alleged lover was a sheriff of Sussex County, New Jersey. He also found a witness that could place Deshong at the Cross Keys Inn. Whatever else William might have been able to discover, we will never know, because he suddenly fell seriously ill—so ill that he was delirious and unable to travel. By the time he regained consciousness, the date of his sister's execution was imminent. Fearing to waste any time, William raced directly to the home of Benjamin Franklin, the President of the Supreme Executive Council, to get a second stay of execution. When Franklin turned him away, he sought the rest of the council but found only Council Vice President Charles Biddle remaining, who hastily scrawled a note to the Chester County sheriff to postpone the execution until he received further instructions.[15]

Armed with this new stay of execution, William somehow had to cross the 15 miles between Philadelphia and Chester before his sister's scheduled time. In the meantime, Elizabeth met with her supporters that morning and spent time in religious devotion, waiting to see if William would return. When her time arrived with no sign of reprieve, Elizabeth accepted the news quietly. She was escorted to an old cherry tree at the corner of Providence and Edgmont Streets, where the gathered crowd heard sermons and prayers, and Elizabeth asked that her confession—her second confession, featuring Deshong—be read aloud. The reading of a penitent confession at the site of an execution was quite common in the eighteenth century, and Elizabeth's confession hit all the expected points—she affirmed that what she confessed was the truth, she prayed that others might learn from her sorry end, she forgave all that had injured her and asked forgiveness for her sins.[16]

The execution had been delayed as long as possible to give William time to return with the pardon, but at some point, Elizabeth was told her time had come. According to the report of her execution:

> In her last moment she appeared perfectly calm and resigned; took an affectionate leave of the minister, no longer able to bear the sight, and said "she hoped to meet him in a better world." The moment before she was to be turned off the sheriff asked her if with her dying breath she sealed the confession she had made?

When she understood who spoke to her, she moved her hand and said: "I do, for it is the truth."And in a moment was turned off, and quickly left the world, in exchange, we hope, for a better. But here we must drop a tear! What heart so hard, as not to melt at human woe![17]

Twenty-three minutes later, William raced into the intersection with the stay of execution in his hand, but it was far too late to save his sister. The next day she was interred, reportedly in an unmarked grave, but attended by a large number of mourners.

The great question remains: did she, or didn't she? Meredith Tufts argued that Elizabeth's eleventh-hour change of story featuring an entirely new narrative, a mystery lover, an alias, and promises of marriage, was a desperate bid to save a guilty woman from the hangman's noose.[18] But it was almost immediately clear that her story resonated with a post-Revolutionary public that distrusted the Concealment Statute and operated under a romantic belief in the inherent compassion and maternal inclinations of womanhood.

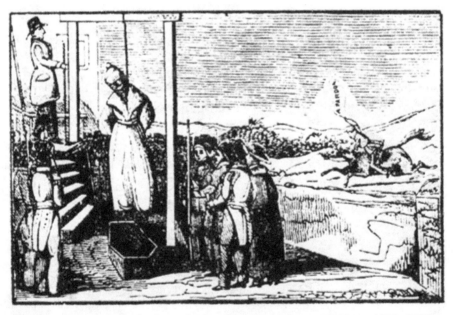

Title page artwork from the first edition of *The Pennsylvania Hermit*, c. 1838. William can be seen on horseback calling "A pardon!" (Wikimedia)

To understand the dichotomy between the two faces of Elizabeth Wilson, we must understand the story that has come down the generations. Although arguments over her guilt or innocence began almost immediately after her execution, the most popular versions of her story emerged in the nineteenth century. Among the first were articles published in the *Delaware County Republican* (first in 1854 and again in 1877) which painted her as a virtuous young beauty whose mother had died when she was young, leaving her without the much-needed maternal hand to guide her own behavior. In this version, she fell victim at the age of 17 to an unscrupulous seducer who left her pregnant and abandoned, and who later endured the trauma of a stillborn child. She fled to Philadelphia with her reputation in ruins, only to suffer the ill fortune of falling for another deceitful suitor.[19]

In 1884, Henry Graham Ashmead took up Elizabeth's banner and borrowed heavily from the *Delaware County Republican* stories to craft his own narrative. In Ashmead's version, Elizabeth's father was a poor, but esteemed, member of the community and her mother died when she was a child. Ashmead whitewashed Elizabeth's earlier sexual misadventures and the children that resulted from them and led the reader to assume she fell victim to a single devious seducer—he even informs the reader that she was as a child an adherent of the Baptist clergyman named Elder Fleeson. Ashmead embroidered her tragic tale by having her return home to her family to bear her children and wove in an immense piety and love for her newborns. Instead of pleading her case in jail and during her trial, Ashmead told the reader that she was mute and wallowing in her own sorrow, unable to even summon the energy to defend herself, and that Judge Atlee "knowing that to proceed meant conviction for the prisoner, in the goodness of his heart ordered that the trial should go over to the following term."[20] Elizabeth's response to any question put to her was "weep[ing] passionately," "weeping violently," or an "outburst of tears, which would continue for hours," interspersed with "constant prayer."[21] Even the gender of her babies changed from female to male, as though the murder of boys is somehow a far greater loss. In his recounting of William's race to save his sister's life, Ashmead described

with great relish how, when faced with an ice-choked Schuylkill River and no way to ferry across, he drove his horse into the freezing waters—and when the horse drowned, he swam the remaining distance. As a result, William is given a Christlike aspect against Elizabeth's virginal innocence. Ashmead even alludes to that other beneficiary of nineteenth-century romanticism by noting that Elizabeth was taken to "a white cherry-tree on 'Hangman's Lot,' at the intersection of Edgmont and Providence Avenues ... whereon a little over seven years previously James Fitzpatrick had met his fate."[22]

Elizabeth's narrative took on a life of its own after her execution, growing and changing at the whim of whichever society retold it. In an America fresh out of battles for independence and justice, outrage centered around an unpopular law that citizens of Philadelphia had long believed to be unfair, which had not given Elizabeth the proper time to prove her innocence. The question wasn't about what kind of person Elizabeth was, but whether she had been treated fairly by the courts. Over time Elizabeth herself began to change until she arrived in the Victorian era as naive, pious, and obedient to men, no matter what station they held in her life. In these later accounts William became her only source of earthly salvation, as her real-life testimony was swept under a rug of "womanly" silence, in which she sat suffering in her own quiet misery in jail for months rather than speaking out in her own defense. Even the jurors and judge are robbed of their agency by being assigned roles in which they believed and supported Elizabeth but were hamstrung by the rigidness of Pennsylvania laws and the unforgiving Philadelphia weather—neither of which any mere man is expected to conquer, thus removing responsibility for any action in this narrative from anyone, really. The hanging of Elizabeth Wilson became a sad moral tale in which nothing was anyone's fault, except maybe for that nebulous seducer, Joseph Deshong—who, as far as anyone can tell, was never given the chance to tell his story, either.

It may be of interest to the reader to know what life was like for William after his failure to save his sister's life. Ashmead reported that when he saw his sister dead, William lost consciousness, and when he was resuscitated his dark hair had turned entirely white from the shock.[23]

He could not bear to be among civ-
ilized people anymore and removed
himself to Dauphin County to live as a
hermit in the caves in Hummelstown.
Today known as Indian Echo Caverns,
William's cave was particularly large,
with a natural ledge reputed to have
been William's bed and a recess in the
floor he used as a fire pit. William
wrote extensively on religion, and
made grindstones which he sold to
a local farmer in exchange for goods
and supplies. He died in October
1821, and himself became the subject
of folklore. Shortly after his death a
manuscript called *The Pennsylvania
Hermit: A Narrative of the Extraordinary
Life of Amos Wilson* was published,
purportedly by a "friend" who visited
Wilson the night before he died. The
question of why William's name was
changed to Amos for this publication

William Wilson as depicted in an
illustration from the first edition of
The Pennsylvania Hermit, c. 1838.
(Wikimedia)

remains unexplained, and obviously casts doubt on the work itself. The
first part contains numerous errors, including listing Elizabeth's birth year
as 1776 (which would have made her nine years old when she died).
The second part, called *The Sweets of Solitude*, was alleged to have been
written by William himself and contains admonitions to live a life of
blessed righteousness:

> Religion is the balm that heals those wounds; it was this that preserved me and
> prevented my committing violence on myself ... when doomed to witness the
> melancholy fate of an affectionate and only sister, the companion of my youth,
> torn from the bosom of her fond parents, and for many months confined within
> the thick walls of a gloomy prison, and from thence conveyed (at the very moment
> that a pardon was obtained for her) to the gallows, there to suffer like one of the
> greatest monsters of human depravity, an ignominious death!—to view her lifeless
> corpse suspended in the air, surrounded by a throng of spectators!—but alas!

It was the will of God to which we must submit—it was at this trying moment that he sent Religion and reason to my aid, and bid me no longer grieve for her who I could not and ought not wish to recall to this troublesome world—for her whom I had just reason to believe had gone to the regions of eternal day, above the reaches of sorrow, vice, and pain.[24]

Visitors to Indian Echo Caverns can still tour "Wilson Cave" and see where William spent the last 19 years of his lonely life.

Notes

1 Meredith Peterson Tufts, "A Matter of Context: Elizabeth Wilson Revisited," *The Pennsylvania Magazine of History and Biography*, Vol. 131, No. 2 (April 2007), 149–176.

2 Ibid., 156–157.

3 Ibid., 156.

4 Ibid., 158.

5 Clare A. Lyons, *Sex Among the Rabble: An Intimate History of Gender and Power in the Age of Revolution, Philadelphia, 1730–1830* (Chapel Hill, NC: University of North Carolina Press, 2006), 64.

6 G.S. Rowe, "Infanticide, Its Judicial Resolution, and Criminal Code Revision in Early Pennsylvania," *Proceedings of the American Philosophical Society*, Vol. 135, No. 2 (June 1991), 347.

7 Lyons, 110.

8 Ibid., 107–109.

9 Tufts, 165, 169.

10 Ibid., 166.

11 Ibid., 168–9.

12 Ibid., 168–9.

13 Rowe, 353.

14 Tufts, 170.

15 Ibid., 171–2.

16 *"A Faithful narrative of Elizabeth Wilson; who was executed at Chester, January 3d, 1786. Charged with the murder of her twin infants. Containing some account of her dying sayings; with some serious reflections: Drawn up at the request of a friend unconnected with the deceased,"* 1786. Available from https://quod.lib.umich.edu/e/evans/N15436.0001.001/1:2?rgn=div1;view=fulltext;q1=Hymns.

17 *"A Faithful Narrative…,"* 6.

18 Tufts, 174–175.

19 Ibid., 151–2.

20 Henry Graham Ashmead, *History of Delaware County, Pennsylvania* (Philadelphia: L. H. Everts & Co., 1884), 173.

21 Ibid., 172–3.
22 Ibid., 175.
23 Ibid., 175.
24 Amos Wilson, *The Sweets of Solitude! Or Directions to Mankind How They May Be Happy in a 'Miserable World!'* Available online at http://seclusion.com/the-sweets-of-solitude/the-sweets-of-solitude-the-manuscript/.

Buried in Two Places: Mad Anthony Wayne's Gruesome Final Journey

In a Google search that is certain to add my name to some sort of watchlist, I looked up how and why someone would want to deflesh a human body by boiling. The process of defleshing is, by the way, called *excarnation*, from the Latin *excarnare*, "to remove flesh." It turns out that excarnation has been used widely throughout history, both as part of funerary rights as well as a practical way to avoid decomposition while transporting the bodies of nobles over long distances. Until the early Middle Ages, cremation was the logical solution to carrying a deceased loved one over the bumpy, muddy roads of antiquity. King Charlemagne, however, outlawed cremation upon pain of death, which left travelers in a bit of a conundrum. As a result, the practice of *Mos Teutonicus* ("the German custom") emerged in the tenth and eleventh centuries. Especially during the Crusades, when European nobles—mostly Germans, hence the name—found the idea of being buried in Muslim territory abhorrent, *Mos Teutonicus* resolved the issue of transporting bodies long distances without dealing with the smell, insects, bacteria, and leaked fluids of a decomposing corpse. The other option was embalming, which seemed more to the taste of the English and French aristocracy. Embalming was expensive, but in a world that viewed decay as a sign of sinfulness, any expense was worth being able to thumb their patrician noses at the natural putrefaction of their carbon-based carcasses. In 1300, Pope Boniface VIII removed even the shortcut of *Mos Teutonicus* in a papal bull outlawing the practice, although oddly while boiling the dead was illegal, boiling live people *to* death was a perfectly acceptable form of execution.

The practice of *Mos Teutonicus* died out in the fifteenth century with the end of the Crusades except in rare circumstances.

This chapter is about one of those rare circumstances.

Anthony Wayne was born on January 1, 1745, one of four children of Isaac and Elizabeth Iddings Wayne at the family farm and tannery called Waynesborough in Chester County. Isaac envisioned a scholarly life for his son, enrolling him in a local academy run by his uncle Gabriel with an eye toward learning Latin, Greek, the history of England and Rome, and other subjects deemed necessary for cultivating a well-rounded gentleman farmer. Young Anthony, however, showed little interest in book learning—he lived out his childhood and adolescence against the backdrop of the French and Indian War (1754–63), which proved much more appealing than dead ancient languages. Still, Isaac held out hope that his son would become a polished and respectable young man. Uncle Gabriel, from his perspective as Anthony's teacher, was less optimistic. In a letter to his brother Isaac, Gabriel wrote:

> I really suspect that parental affection blinds you, and that you have mistaken your son's capacity. What he may be best qualified for, I know not—one thing I am certain of, he will never make a scholar, he may perhaps make a soldier, he had already distracted the brains of two-thirds of the boys under my charge, by rehearsals with battles, sieges, etc.—They exhibit more the appearance of Indians and harlequins than students.... During noon, in place of the usual games of amusement, he had the boys employed in throwing up redoubts, skirmishing, etc.[1]

Upon hearing this sour report, Isaac took his son in hand and threatened to make him do the worst jobs on the farm until he shaped up. Since Isaac had set up a prosperous tannery on the property, the threat was a very real one—tanning involved skinning an animal while the flesh was still warm, then curing it with salt to prevent bacterial growth until it was ready to be processed. In processing, the tanner removes the hair and grease from the skin, then soaks it in water for up to two days. Needless to say, being given the worst aspects of a farm that tanned hides was quite a punishment indeed, and it scared Anthony enough that he soon became the best student in his uncle's school. At 16, Anthony enrolled in the College of Philadelphia and spent two years there, where he learned the history of Julius Caesar and the Roman Republic—knowledge which

would later shape his military career. But in the present, the dream of becoming a soldier remained just that—a dream. As a colonial, Anthony Wayne would never be able to enter the British Army without purchasing commissions, which were so expensive that only the wealthiest British aristocrats could typically afford them. Anthony Wayne instead set up shop as a surveyor, which at least kept him active.[2]

In 1766, Anthony married Mary Penrose, who went by the nickname "Polly." Polly had visited the Wayne family the previous Christmas as a guest of Ann Wayne, Anthony's younger sister, and Anthony was instantly smitten. They were married in March, just three months after meeting, and in 1770 they welcomed their first child, Margaretta. In 1772, son Isaac arrived, named after his grandfather. For a time, they were happy—Polly got along well with Anthony's parents, and the tanning business was growing with trade to the West Indies. But all good things must come to an end, and so it went with Anthony Wayne's family life. Throughout the 1760s, the government of Great Britain

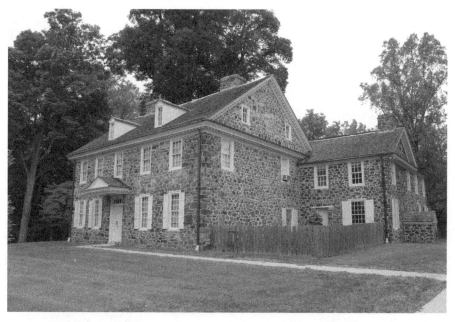

Historic Waynesborough 2012. (by Justine Gluck / CC-BY-SA-3.0. Wikimedia Creative Commons)

began imposing heavy taxes on the American colonies in an effort to pay down the debts incurred during the French and Indian War. To the English, it was only fair that the colonies contribute to the cost of a war fought largely on colonial soil, while the Americans bristled at taxes being imposed upon them without their opinion on the matter. These taxes targeted a variety of products that Americans depended on; any form of printed paper, including playing cards, newspapers, and official documents; paint; glass; lead; and tea. This last item in particular led colonists to boycott tea, leaving the British East India Company with millions of pounds of surplus product. John Hancock and Samuel Adams, for example, made a living for a little while smuggling tea in from Holland. When ships carrying British tea landed at Boston and demanded that the tax be paid, the Sons of Liberty raided the ships in the middle of the night and threw the cargo overboard, ruining 342 chests of British-owned tea.

While many Americans supported the act of resistance later known as "The Boston Tea Party," others weren't so sure that vandalism was the best solution. Benjamin Franklin believed that the destruction of private property was uncalled for and felt that the British East India Company should have been reimbursed for their losses. Retribution for the act was swift; in 1774 the British passed the Coercive Acts as a way to punish Boston for its behavior. The Coercive Acts called for the closing of Boston Harbor, which would financially ruin the city and prevent supplies from being imported; ended free elections; and put British officials in charge of colonial business. If Britain hoped to quell rebellion with punishment, the Coercive Acts not only failed in bringing the irate Bostonians to heel—it infuriated all of the other British colonies as well.

In 1774, Anthony Wayne joined the Assembly at Philadelphia to discuss what to do about the rising tensions with England, and the group decided to release its *Declaration and Resolves,* which censured Britain for its conduct, established a boycott of British goods, and called for the training of a colonial militia (an aspect which must have excited Anthony Wayne to no end). Before the Boston Tea Party, King George III famously told Lord North "The die is now cast, the colonies must either submit or triumph."[3] His opinion after the *Declaration and Resolves*

remained unchanged, and in April 1775 the war began with the first shots at Lexington and Concord.

Anthony Wayne joined the Continental Army and raised a Pennsylvania militia, and would from that point on become a stranger to his home and family. His visits to Waynesborough were sporadic and short, sometimes with years between them. He had finally achieved his boyhood dream of being a soldier, and his family was reduced to a fond side note to his exciting new life. He did maintain a correspondence with Polly, giving her instructions about the farm and the education of their children, but also writing to her frequently on the eves of his various battles, when he contemplated his own mortality. During the long war, he served at the Invasion of Quebec, the Philadelphia Campaign, the Yorktown Campaign, and the disastrous battle of Paoli. In war he was fearless, which may have eventually earned him the nickname "Mad" Anthony Wayne.

In one of the greatest ironies of Wayne's life, the most severe injury he sustained during the war was getting shot in the thigh—by a startled sentry at the camp of the Marquis de Lafayette who mistook him for British. He recovered from that friendly-fire wound, but Wayne was convinced that the musket ball entering his thigh had somehow caused gout in his foot, as he first felt its pains that same day. Though the term "gout" might have referred to a few different similar afflictions, generally it meant a form of arthritis brought about by an excess of uric acid in the bloodstream. Pain can often come on suddenly and is typically excruciating in the joints, especially in the big toe. Today it can be managed using anti-inflammatories, but in the eighteenth century there were few options for pain except alcohol, which can often exacerbate the condition.

Between 1775, when Wayne joined the army, and 1783, when the war ended, the relationship between Wayne and his wife and children gradually deteriorated. It was becoming clear to Polly that her husband cared more for battles and soldiers than for his family. Polly's letters to Wayne, at least at the beginning, are filled with love and longing for his safe return. His are filled with news about himself, or detailed descriptions of troop movements and battles. When he returned to the area for what

Anthony Wayne as a young man. (*National Portrait Gallery of Eminent Americans from original full length portraits by Alonzo Chappel* Vol I, New York: Johnson, Fry & Co. 1862. Wikimedia)

would be the battle of Brandywine, he was camping within 20 miles of Waynesborough but never attempted to visit his family. Historian Mary Stockwell noted the shift in the family dynamic:

> As the war dragged on, and Wayne still did not come home, Polly no longer wrote to him with the same affection. She realized Anthony cared little for her troubles, and even when he did, he showed no sympathy, writing to her instead about patriotism and honor as if he was talking to his troops She still reported how things were going at Waynesborough, including the various illnesses of family and friends But all her descriptions of longing to be with him and flying to the door at the sound of an approaching horse disappeared from her letters. She also stopped referring to "their" children and now wrote to Wayne about all the happenings in the life of "my daughter" and "my son."[4]

Though the war lasted much longer than anyone—American or British—expected, it did finally come to an official end in 1783 with the signing of the Treaty of Paris. For Anthony Wayne, this meant the end of the single greatest experience of his life. For eight years the founding fathers had fought, bled, slept, ate, and commiserated together, and now the army prepared to finally disband. The officers, including men like Washington and Wayne, feared that 13 colonies, united for the first time in one single powerful movement, might begin to drift apart again. It was Henry Knox, commander of the artillery during the war, who came up with the idea of a continuing fraternal organization for those who had fought in the Revolutionary War. It would be called the Society of the Cincinnati, named after the Roman hero Lucius Quinctius Cincinnatus, who had refused rewards for his service to Rome. For the veterans of the Revolutionary War, who were going home without many months of pay and without any sure prospect of financial reimbursement anytime soon, the civic virtue of Cincinnatus rang a bell of truth. Each state formed its own branch of the Society, with George Washington serving as its first president general. Anthony Wayne was elected the first Vice President of the Pennsylvania Society of the Cincinnati.

At the end of the war, instead of returning home to Pennsylvania, he traveled south to Georgia. While there he negotiated treaties with the Cherokee and Creek tribes, for which the state of Georgia rewarded him with a large rice plantation. He also contracted malaria, the effects

of which would crop up as intermittent fevers for the rest of his life. He finally returned home to Waynesborough in 1784, but only stayed there a year before moving to Georgia semi-permanently to tend his new plantation. In 1791, he served a year in the Second United States Congress—as a delegate from Georgia—but after allegations of election fraud and his residency qualifications, he lost his seat. Stung, he refused to run for reelection in 1792. He settled into an ignominious retirement, reminiscing about his glory days, well-fortified with Madeira, brandy, and rich foods. He grew older, he grew fatter, and he battled daily with pain from old wounds and gout. He sunk into debt, and into depression. He owed so much money to foreign creditors that he told Polly he was putting Waynesborough up for sale—without consulting his wife or children about where they would live. He tried selling the plantation, but no one wanted it. His family came to the firm conclusion that Anthony Wayne cared little about anything but Anthony Wayne. But he still enjoyed the reputation he had earned during the war—enthusiastic, fearless, and a brilliant tactician. And when George Washington needed someone to turn the flagging American army around, he called on Wayne.

Washington recalled Wayne to command a newly formed military force called the "Legion of the United States" to fight in the Northwest Indian War. The Northwest Indian War began in 1785, as a loose confederation of Native American tribes in the Great Lakes region resisted the encroachment of American settlers into their ancestral lands. The United Indian Nations, as the confederation called itself, included the Wyandot, Shawnee, Lenape, Miami, Wabash, Iroquois and Kickapoo tribes, among others. At the beginning of the war, the American forces were ill trained and poorly deployed, which resulted in a string of losses against the United Indian Nations. Though poorly funded and disastrously supplied, Wayne managed not only to train up the first of America's standing armies, but to also establish a string of forts in the west to safeguard the supply chain and maintain order into the future.

While Wayne was engaged out west, he received reports through the early months of 1793 of his wife Polly's failing health. Letters from friends and family urged him to write home, to make contact. Polly hadn't written to him since May 1792, and he didn't seem inclined

to write to her either. His daughter Margaretta's husband urged him to at least "remember you have a Daughter who loves you to excess scarcely equaled."[5] Despite these entreaties to write, and frequent warnings of Polly's ill health, somehow her death on April 18, 1793 still shocked him and sent him into a deep depression. In the following months, he attempted to resurrect his relationship with his son, Isaac, who at 22 years old was a hardworking student of the law. They began exchanging letters, and Wayne confided in his son the same way he had once confided his worries and plans to his wife. Inexplicably, he never did write to his daughter Margaretta, even after she lost both her mother and her infant son in the same year.

Fearing that he would die in battle, and agonized by the constant pain in his leg from gout, he made out his final will and wrote Isaac letters full of the kind of fatherly advice he had not shared through the first two decades of Isaac's life. Anthony resorted to tightly wrapping his arms and legs in flannel every morning and imbibing larger and larger amounts of whiskey to dull the pain. On more than one occasion, he had to be carried from his bed to his horse.

Despite the lack of supplies and support from the government, and in the face of a strong and well-organized confederacy of tribes, the steady hand of Anthony Wayne turned the tide in the Northwest Indian War. In August 1794, the United Indian Nations suffered a crushing defeat at the battle of Fallen Timbers; a year later, in August 1795, Wayne negotiated the Treaty of Greenville, which formally ended hostilities between the Americans and United Indian Nations and ceded most of Ohio to the United States.

Anthony Wayne the year before his death, in the uniform in which he would be buried. Pastel by James Sharples, Sr. (Wikimedia)

After the signing of the Treaty of Greenville, Wayne realized that it was

finally time to go home—for good this time. He arrived in Philadelphia in February 1796 to enormous fanfare, the likes of which he had never experienced in his long career fighting for the American cause. His stay at Waynesborough, though, was fraught with tension, as what was left of the Wayne family struggled to rebuild a relationship that had ceased to exist in 1775 when Wayne left for war. His interactions with Margaretta were especially cold; small wonder, considering the almost negligent way he had treated her in the past. The Hero of Greenville soon found more congenial company in Philadelphia, where he was feted and surrounded by entertainments and beautiful women. Once again, his family was left behind.

In May 1796, George Washington asked Wayne to complete one more task—to oversee the return to the United States of the western forts taken by Great Britain. Never one to turn down a request from the Father of the Country himself, Wayne agreed. He rode out of Philadelphia for the last time in June 1796 with citizens applauding him the entire way. When he arrived at Fort Miamis on August 7, 1796 he oversaw the symbolic transfer of the British territory to the United States. By the middle of August, Wayne had largely completed the task set before him.

In November, he decided to leave Detroit, where he'd been residing for several weeks, to head toward Pittsburgh. He had developed a persistent fever that he treated with large doses of quinine, but otherwise felt pardonable in both body and spirit. But before long, his leg—the leg that still held that friendly-fire musket ball—swelled up. His ship docked at Fort Presque Isle, a stop between Detroit and Pittsburgh, and by that time he was unable to walk. Wayne was carried up to the second floor of the fort, where his arms and legs were tightly wrapped in flannel. For two weeks, Wayne slowly recovered, but on December 1, 1796 he complained of severe pain in his stomach. He cried out that he thought his gout had finally moved into his stomach and bowels. The agony increased; an army surgeon named George Balfour bled Wayne, which caused so much weakness that the general finally slept. When he woke, he told the commander of the fort that he was dying and to bury him at the

The blockhouse at Fort Presque Isle where Anthony Wayne died. (Erie County Historical Society)

foot of the fort's flagpole. In the wee hours of December 15, 1796, Wayne passed away.

General Anthony Wayne was dressed in his blue and white uniform and placed in an oak casket. The men drove brass tacks into the lid of the casket, spelling out the date of his death, and he was buried on a hill overlooking Lake Erie. Two weeks later, Isaac learned about his father's death, and his heart broke that he was buried so far away, in such a lonely, cold place. But his father had died as he had lived—in the company of soldiers.

The years passed, and America started to lose its founding fathers one by one. Benjamin Franklin died in 1790, John Hancock in 1793. The great George Washington died in 1799, as did Patrick Henry. Samuel Adams died in 1803. Alexander Hamilton followed in 1804, murdered by his colleague Aaron Burr. John Dickinson, known as the "Penman of the Revolution," died in 1808. Worse, the Society of the Cincinnati had begun to fail. Of the state delegations, those of North Carolina,

Georgia, Delaware, and Connecticut had dissolved by 1804. It was time to start salvaging the memories and honor of those who had fought for independence.

While recognition of Revolutionary War soldiers was gaining renewed interest, the Wayne family had its own health struggles. In the fall of 1808, Margaretta came down with a serious illness. She suggested to Isaac that they should consider bringing their father's remains home to the family burial plot in Radnor, to reunite the family in death, at least, and to allow for their father to be properly honored. The Pennsylvania Society of the Cincinnati pledged to raise money for a proper monument for Anthony Wayne nearer to Philadelphia, and Isaac decided that it was time to bring his father home.

Since travel in the winter would be difficult, if not downright danger-ous, Isaac resolved to start for Fort Presque Isle in the spring. When the weather warmed, he drove a small two-wheeled wagon to northwestern Pennsylvania, a journey of some 400 miles. The small vehicle was just big enough to bring his father's bones back to Waynesborough, since 13 years should have been plenty of time for Wayne's remains to decay. He arranged for Dr. J. C. Wallace to handle his father's disinterment, as he himself did not want to be present for such an event. He preferred to preserve the memory of his father as a hero, full of life and joy.

In a solemn, small ceremony, Anthony Wayne's coffin was exhumed, and the lid opened. To the shock and horror of everyone present, they discovered that his body had barely decomposed. Only one leg and foot was partially gone; the rest of the body remained much as it had been when it was buried. A witness later recalled that Wayne's body was not hard but had the consistency of soft chalk. Another observed that the flesh on Wayne's backbone was "four inches thick solid and firm like new pork."[6] This presented a problem, since Isaac's sulky wasn't big enough to carry a full coffin with remains inside of it, and what was left of his father would surely start to rot when exposed to the warmth of traveling in the sun. Like the crusaders of medieval times, the health risks of traveling with a rotting corpse were very real, not to mention the general unpleasantness. At the same time, Isaac had traveled 400 miles and could not fail in his mission to bring his father home.

It was Dr. Wallace that proposed the solution used by European soldiers for centuries. With the help of four assistants and a disconcerting number of spectators, Wayne's body was divested of its rotting uniform (but reportedly one spectator nabbed his one remaining good boot and had another boot made to match). The group procured as large a kettle as they could find, but the body still had to be cut up into manageable pieces,

The pot in which General Anthony Wayne's remains were allegedly boiled. (Erie County Historical Society)

which they dropped into the boiling water. As the flesh loosened on each dismembered piece, the doctor and his assistants scraped the bones clean and placed them in the trunk Isaac had brought with him. When the grisly task was complete, the doctors poured the water from the kettle, the flesh, and the tools into the casket and reburied it in the original grave.[7]

In retrospect, Isaac might have made different choices. Had he known the state his father's remains were in, he might have elected to leave them in Erie. But with the deed done, he returned to southeastern Pennsylvania with the solider half of his father's remains in the back of his cart. General Anthony Wayne's bones were reburied in the family plot at St. David's Episcopal Church in Radnor, and the Pennsylvania State Society of the Cincinnati, as promised, raised $500 to erect a proper monument for the grave. During the dedication of the monument, the funeral procession spanned over a mile long.

While Wayne's grave in Radnor was clearly marked and honored, his *other* grave in Erie was lost after a fire at the fort destroyed the buildings. Years later the old parade ground was leveled, and no one could remember where the original grave was. In 1878 the grave was rediscovered, identified by the remaining parts of the coffin lid with its brass tacks,

scraps of clothing, and the tools used in the excarnation process. All of these artifacts went on display and are now in the collection of the Erie Historical Society. In 1880, the blockhouse was rebuilt as a monument to General Wayne and has been maintained and rebuilt several times since then.

The life, death, and unexpectedly dramatic afterlife of General Anthony Wayne are the stuff of fever dreams, where the events that unfolded are so unbelievable that they can only be true. When I first heard the story, I had to reach out to the Erie Historical Society to verify that it was factual. I could not imagine any circumstance where I could be convinced to dig up my dad's body, cut it into pieces, then boil and scrape it. The more research I did, however, the more I realized that I was layering twenty-first-century scruples onto nineteenth-century circumstances. As illustrated in the beginning of the chapter, excarnation was not a new practice. Historians estimate that around 24,000 Americans died in battle and from disease during the Revolutionary War, and up to 25,000 British soldiers died as well. These were almost all soldiers that died far from home, and it's reasonable to assume that their remains might have been moved after the fact. Had Anthony Wayne decomposed as he was supposed to, we would not be talking about his relocation with the same degree of horror. Why, after 13 years, was Anthony Wayne's body still so intact? Some theorize that the cold, windswept Erie weather preserved him longer than was common in the rest of the country. Some theorize that the extraordinary levels of uric acid in his body, as a result of his gout, might have played some part in preserving him. Some even theorize that he was poisoned by political enemies, and some concoction of mercury, arsenic or antimony prevented his tissues from breaking down as they normally would.

In addition to the distinction of being a Founding Father, the exhumation of Anthony Wayne initiated him into a rarified group—the Incorrupt. Whatever you believe happens to the soul when a person dies, the end result for the body is pretty predictable. Once the blood stops pumping, decay sets in. It might take more than 24 hours to notice it, but the decomposition process has already been hard at work to render

the flesh into useful nutrients for the earth. This process can be arrested, of course—but it requires that certain conditions are met. These are some of the ways in which bodies can be preserved:

- *Mummification.* Made famous by the ancient Egyptians, mummification was a method of artificial preservation. The internal organs were removed; the body cavity was filled with herbs and other materials to remove moisture and prevent bacterial growth; and the body was wrapped in linens and covered in natron. Natural mummification can occur, and is most often seen where soil is salty and dry. It can also happen in areas where peat bogs are prevalent, since the humic acids produced in bogs can saturate body tissues and prevent decay.[8]
- *Modern Embalming.* Once men began to understand the circulatory system, they soon realized that they could inject chemicals into veins and arteries in order to forestall decomposition. Embalming began in the mid-eighteenth century but emerged into the mainstream in the nineteenth century with the Civil War.[9] Though embalming was available at the time of Anthony Wayne's death, there is no indication that his remains went through such a process.
- *Freezing.* Though not usually intentional (at least until the twentieth century) freezing is an exceptionally effective means of preserving the deceased, since it stops the decaying process in its tracks at or close to the time of death. Famous examples of preservation by freezing include John Torrington, an English officer who died on an Arctic expedition in 1846 and was discovered in 1984; *La Doncella*, the body of a young Incan woman discovered frozen in the Andes Mountains; and "Green Boots," an unidentified Mt. Everest climber who has become a macabre landmark for other men and women attempting the summit. The idea of freezing a recently deceased body in the hopes of resurrecting it at a future date was popular in the 1960s and 1970s but the cost (up to $200,000 for just the initial freezing) has diminished demand—although some life insurance companies now offer policies that will pay for part of the expense of cryonically preserving the recently deceased.[10]

- *Mellification and Alcohol.* As an early form of embalming, submerging the dead in honey was remarkably effective due to honey's antibacterial properties. Alexander the Great was reportedly embalmed in honey; Lord Admiral Horatio Nelson, after his death at the battle of Trafalgar, was preserved in brandy.[11] There was no evidence that Anthony Wayne's body was treated with alcohol, and even with his prodigious consumption of whiskey, it is unlikely that this had an effect on his body after death.

An "incorruptible" is a person whose body did not decay in the expected fashion after death, without the presence of any of the preservation methods listed above.[12] When we think of the "incorrupt" today, we usually think of the remains of Catholic saints. When a man or woman was being considered for sainthood, their corpse was exhumed in preparation for moving it to another place of honor. During that exhumation, the saint-to-be was sometimes found in a state of "holy incorruption," which was thought to occur if the deceased was filled with a superabundance of "holy spirit" when they died. Historically, being found in this state served as its own sort of miracle and provided proof of the person's qualification for sainthood. The state of being "incorrupt" was often fleeting; removing a body from the environment in which it had been preserved might hasten its decay, which is why so many bodies of so-called "incorrupt" saints are presently in a state of ... well, more than a little bit of corruption. Sometimes the saint's remains were dismembered and sent to different parishes as holy relics; one church might have a head, one might have a hand, and another might have a heart.

In the twentieth century, the Catholic church stopped using incorruptibility as a sign of beatitude, namely because embarrassingly, a lot of people turned up insanely well preserved despite not being Catholic—Protestant Anthony Wayne among them. In lieu of any concrete evidence of what caused Wayne's exceptional physical longevity, the reader is left to draw their own conclusions. What is certain is that Anthony Wayne sought out a remarkable life and a memorable death, and on both notes, he succeeded beyond his wildest dreams.

The grave of General Anthony Wayne at St. David's Episcopal Church in Wayne, Pennsylvania. (HABS/HAAR Wikimedia)

Notes

1 Mary Stockwell, *Unlikely General: "Mad" Anthony Wayne and the Battle for America* (New Haven: Yale University Press, 2018), 42.

2 Ibid., 43.

3 Carl G. Karsch, "The First Continental Congress: A Dangerous Journey Begins," https://web.archive.org/web/20120118024728/http://www.ushistory.org/carpentershall/history/congress.htm.

4 Stockwell, 146.

5 Ibid., 137.

6 Hugh T. Harrington and Lisa A. Ennis, "'Mad' Anthony Wayne: His Body Did Not Rest in Peace," https://www.americanrevolution.org/wayne.php.

7 Ibid.

8 "The Perfect Corpse," *Nova*, PBS, accessed March 15, 2021.

9 "Embalming and the Civil War," National Museum of Civil War Medicine, posted on February 20, 2016, https://www.civilwarmed.org/embalming1/.

10 Hannah Devlin, "The cryonics dilemma: will deep-frozen bodies be fit for new life?" The Guardian, posted November 18, 2016, https://www.theguardian.com/science/2016/nov/18/the-cryonics-dilemma-will-deep-frozen-bodies-be-fit-for-new-life.

11 Alexander Meddings, "Tapping the Admiral: The Posthumous Pickling of Horatio Nelson," O Tempora, O Mores, accessed March 15, 2021, https://alexandermeddings.com/history/tapping-the-admiral-the-posthumous-pickling-of-horatio-nelson/.

12 Josh Clark, "How can a corpse be incorruptible?" How Stuff Works, accessed March 15, 2021, https://people.howstuffworks.com/incorruptible2.htm.

Opening the Windows of Heaven: The Flood of 1843

In 1735, Benjamin Franklin, writing as his alter-ego Richard Saunders in *Poor Richard's Almanac,* made the observation of human beings that "some are weatherwise, some are otherwise."[1] It is certainly easy for us to be weather-wise in the twenty-first century, with a staggering array of meteorological technology at our fingertips. Paid, professional weather-people spend the entireties of their work weeks monitoring the slightest changes in wind speed and humidity for indications of what atmospheric conditions we'll enjoy ten days from now. We relax in the comfort of knowing that if something bad is around the corner, we will know about it early enough to prepare. Farmers and florists can cover their delicate crops; homeowners can board up their windows and sandbag their doorways; people who live in flash-flood areas can remove themselves to higher ground.

The ability to foretell our weather future is a fairly recent development; Dr. Cadwallader Colden of Philadelphia bought the first thermometer/barometer for use in monitoring the weather in 1718. The following decades saw scientifically-minded men try their hand not only at recording the weather, but forecasting it as well. In 1743, Benjamin Franklin made plans to watch a lunar eclipse, but a storm obscured his view. In conversing with contacts in Boston, he discovered that they had been able to view the eclipse, and the storm that had hit Pennsylvania with such unfortunate timing had arrived in Boston many hours later. Intrigued, Franklin began monitoring the movement of storms, and in the course of his studies he theorized about the existence of high- and low-pressure

areas. In the years just prior to his death, he used the presence of hail in the summertime to hypothesize that the upper atmosphere must be colder than the air below it.

For Pennsylvanians without the inclination or resources to study the weather on their own, they had to place their trust in God—and an almanac. Almanacs were often a mixture of scientific observation and superstition and provided farmers with at least a thin sense of control over their environment. An almanac could tell farmers what kind of weather was likely to occur and provided them with a blueprint for agricultural success based in the moon and stars: sow grain only when the moon is waxing; plant potatoes only in the "dark of the moon"; slaughter cattle during the full moon; if a rooster crows after 10pm, it will rain the next day.[2] The fact that we in Pennsylvania continue to use a groundhog to predict an early spring is an amusing holdover from a time when these were deadly serious considerations. A late frost could destroy an entire year's worth of food supply.

Meteorology in eighteenth- and nineteenth-century Pennsylvania was especially difficult because the Quaker State is notorious for its reliable *climate*, which provides the ideal temperatures and rainfall for wheat, but wildly changeable *weather*, which can wipe out a bumper crop in the course of a 30-minute hailstorm. Writing to Lord North in 1683, the Proprietor himself, William Penn, noted that "The weather often changeth without notice, and is constant almost in inconstancy!"[3] A prodigiously snowy winter could be sandwiched between two mild winters; a flood year can follow a drought year and be in turn followed by another flood year.

Summers in Pennsylvania were—and continue to be—hot and humid, with about 30 to 40 thunderstorms per year. Pennsylvania's abundant rainfall and plentiful waterways created a farmer's paradise; southeastern Pennsylvania was famous as the breadbasket of the British empire, exporting more wheat and flour than almost anywhere else in the world in the mid- to late eighteenth century. The creeks of Delaware County provided power for 43 textile mills, 32 flour mills, 45 sawmills, eight paper mills, and other mills for processing clover, plaster, and more. More than 45 bridges spanned these creeks, providing reliable transportation routes

Delaware County Historic Mill Sites map, showing Chester Creek (far left), Ridley Creek (middle left), Crum Creek (middle right) and Darby Creek (far right). (Delaware County Historical Society)

from the mills to the ports of Philadelphia, Chester, and Wilmington. In short, it was hard to imagine a place where the events of August 5, 1843 could have been more disastrous.

The summer of 1843 was a season of extremes; in July Philadelphia recorded a sweltering 100-degree day. Despite the record-setting temperatures a month before, the morning of August 5, 1843 was cool and dark, with heavy clouds over the sun that promised a wet day ahead. It started raining at around 7am and continued off and on for most of the day, giving the ground a much-needed gentle soaking. From 7am until that afternoon, about three-quarters of an inch of rain fell. It wasn't even enough precipitation to raise the creeks, which was one reason why no one could have expected what happened next.

Historians looking back at the events of August 5, 1843 often use the modern term "Frankenstorm," and it's a bizarrely accurate description. While the storm was confined mostly to Delaware County (with slivers of Chester County and Montgomery County included), conditions differed from township to township so drastically that one cannot help but think of three or four completely different storms stitched together, which all just happened to occur in the same four- or five-hour period. In the aftermath, the Delaware County Institute of Science was forced to publish their report of the incident neighborhood by neighborhood.

After seven hours of gentle rain, thunder started to roll around 2pm. The clouds lowered, casting shadows over the landscape. By 3pm, it was too dark to read a book without lighting a candle. Residents of Delaware County looked into the skies to see two massive stormfronts—one moving in from the southeast, the other approaching from the northwest—and they were moving *toward each other*. John and George Lewis later reported that they watched the storms collide near Springfield, and they pushed and raged against each other like two boxers in a match, slicing the air with unceasing bolts of lightning and peals of thunder. Eventually the storm from the southeast prevailed, bowling over the northwestern storm and absorbing its power. One witness later described the clouds as being so dense and low that they appeared to "drag upon the treetops." The combined storms brought constant and frighteningly vivid flashes of lightning, followed by ground-rumbling continuous peals of thunder, surrounding the land between in a horrifying theater of light and crashing noise. The lightning and thunder were terrifying on their own, but the strangest part of the storm was the wind.

In the nineteenth century, the term "boxing the compass" came to be used figuratively, but the phrase refers to repeating the 32 points of the compass. This was an apt description of the wind that day, as it veered wildly from southeast to northwest and everything in between. A few witnesses reported very strong winds, and the way they whipped around the points of the compass leveled orchards and fences, scattering trees perpendicular to each other as the winds changed direction. In Bethel Township, the peach trees in Mr. Clayton's orchard fell to the northeast, while the apple trees in the neighboring orchard faced southeast.

The roof of George Miller's house was lifted off and carried away; his clothes, bed, and linens were found a mile away. At John Larkin's farm two miles north of Bethel Township, a straight-line wind obliterated two hundred cords' worth of timber in a narrow swath no wider than two hundred yards. (For a mental picture, two hundred cords of wood are equivalent to around 400 pickup trucks of firewood.) Worse than the wind, the storms also brought with them tornadoes, twisting trees apart at a height of 20 feet or more from the ground and flinging the debris across fields and into houses. Acres of woodland would later be found with ancient oaks torn off midway up the trunks like they'd been shorn by some enormous scythe.

The roiling mass of storm clouds brought unimaginable amounts of rain; when they collided over Delaware County, they unleashed their combined moisture in a blinding torrent. This, too, varied from town to town. Newtown Square reported just over five inches of rain in two hours, but in Concord township a continuous sheet of rain dropped 16 inches in two hours. In Upper Darby, an inch of rain fell in just 15 minutes.

By 7pm the worst of the storm seemed to have moved on, leaving an eerie quiet in its wake. But that quiet was quickly and violently shattered by what the writers of the report can only, insufficiently, describe as the *"phenomenon."* The famous creeks of Delaware County swelled and roiled with rainwater runoff, creating a wall of water that surged down the creeks toward the Delaware River. The Delaware County Institute of Science observed that:

> The description given by many persons of its approach in the lower districts of the county, forcibly reminds one of the accounts he has read of the advance of the tides in the bay of Fundy, and other places where they attain a great height. Some speak of the water as coming down in a breast of several feet at a time; others describe it as approaching in waves which followed each other in rapid succession; but all agree that at one period of the flood, there was an almost instantaneous rise in the water of from five to eight or ten feet.[4]

The word that carries the most weight in this quote is "instantaneous." In a place like Delaware County, whose creeks are dotted by so many mills, dams, and bridges, the result was catastrophic. At the headwaters

of the Chester, Darby, and Ridley Creeks, floodwaters reached depths of ten feet or more, but these areas experienced little damage. An alarming problem was developing further downstream, where the debris from the headwaters began to travel the path of the deluge and pile up against the bridges and mill dams further south and east. The Darby Creek, as it passed through E. Levis' meadow, reached a depth of 14 feet, but a few hundred yards downstream it ballooned to 17 feet as fallen timber formed a natural dam across the waterway. Lying just below this obstruction was Palmer & Marker's stone paper mill, of which more than 30 feet of the building was carried away. Stones from the mill were later found strewn over three quarters of an acre. After that was the cotton factory of John and Thomas Kent; the building and all of its equipment were washed downstream.

During the storm, Michael Nolan had a feeling that his house might be in danger, so he and his son had left their home to seek another place where his family could take refuge. They left Mrs. Dolan, a relative named Susan, and four other children at the house. Having found someone who could take them in, they returned five minutes later to find their house surrounded by floodwater. Mr. Dolan and his son watched desperately from higher ground as the walls of their sturdy home were torn from their foundation. Of those still inside the house when it collapsed, only the two adult women survived, with Susan being rescued from a tree four hours later. The children—James, Thomas, Michael, and Ann, ranging in age from three to fifteen—all drowned. They weren't the only victims of Darby Creek that day. Two men standing on a bridge at Darby were drowned when it collapsed; the body of the first was discovered four days later in a field two miles downstream. The other wasn't discovered for two weeks, buried in a pile of debris. They were only 19 and 21 years old.

The Crum Creek crested even higher than the Darby Creek, at 20 feet, and while the damage to property was devastating at least no lives were lost. The bridge in West Chester at Strasburg Road, which cost $10,000 when it was built and spanned 32 feet, was destroyed, as were the sawmill and plaster mill of John C. Beatty. Beatty recalled the events leading up to the deluge:

At about five o'clock, P. M., the creek began to rise, when several of the workmen, with myself, went to the shop to secure some timber which was afloat and likely to be washed away; but we had not time to make any thing safe, before we were obliged to make our escape, which, if we had not done at the time we did, we must have been washed with the mills down the creek. The water in the space of ten minutes, rose, I think, seven or eight feet. The bridge was the first that went—it seemed to fall over as if there was no strength in it—then my wood-house, with about ten cords of wood and a lot of chestnut rails. Next the head gates were bursted out, when the edge tool factory went down with a tremendous crash, and in an instant there was nothing to be seen but water in the place where it stood. The sawmill was the next to yield to the violence of the flood, and all the logs, plank, boards, &c., near it were carried away. The walls of the plaster mill and finishing mill were undermined, and those in front fell out, leaving the back and end walls in such a wrecked condition, that they fell in a few days after. About half the race bank, and eight yards of the breast of the dam, were completely swept out. All the hammers, anvils, unfinished tools, coal, &c., were swept away, or covered with stones and dirt below.[5]

All of this debris careened next through a roofed lattice bridge with a 90-foot span, then filled the tenant houses of the Strathaven and Avendale cotton factories up to the second floor, forcing their inhabitants to take refuge on the roofs. The water rose so rapidly that the Avendale factory workers didn't have time to rescue the five horses in its stable; all five animals drowned.

On the Ridley Creek, the first property to sustain damage was Amor Bishop's mills (in Ridley Creek State Park), and two of the tenant houses were carried away entirely. By the time the waters reached the woolen factory of Samuel Bancroft, they were 20 feet deep and at their most destructive. The flood picked apart a 50' × 36' section of the mill and wiped four houses nearly off their foundations. One of those houses belonged to George Hargraves, who lived there with his wife, five children, and George's brother William in the middle of a series of four rowhomes. In attempting to move their valuables out of the basement to save them from damage, the Hargraves family didn't see the waters rising around the house. By the time they did, it was too late. They retreated to the second floor, where they hid in a bedroom, with Jane Hargraves clutching her infant in a corner of the room. William, leaning against a wall, suddenly felt the wall flex—then it broke free, and he,

George and four of the children were washed into the creek. Jane and the baby survived because the corner where she stood, only a few feet wide, remained attached to the wall. Amazingly, on the other side of the wall in the neighboring rowhouse stood Thomas Wardell Brown, his wife and child, who also survived. William later reported that he was washed half a mile down the creek, repeatedly struck by debris, until he managed to grasp the branches of a tree and drag himself out of the water. He saw his brother George and the four children go by him on a bed, and George cried out "Hold on to it, William!" George had barely gotten these words out of his mouth before the water flipped the bed, scattering him and the children into the debris-choked Ridley Creek. Their bodies were found a mile downstream. George was 38 years old; Sarah was 13; Andrew was 11; George was nine, and little Samuel, found clasped in his father's arms, was only six. Ridley Creek ultimately crested at 21 feet.[6]

The worst of the damage, and the highest number of casualties, was to come in the most westerly of the affected creeks, Chester Creek. Chester Creek has two branches, the east and west. On the east branch, which rose more rapidly than the west, the waters carried off the entire tilt mill of Thomas Thatcher except "the tilt hammer and the grindstone." Almost every mill, dam, and bridge below the tilt mill were either seriously damaged or destroyed. Though the east branch rose more rapidly, it was on the west branch that the flood achieved its most destructive levels. First an outbuilding of James M. Wilcox's paper mill was relocated several feet in its entirety. Further downstream, the home of a Mr. Kenworthy was carried away, though he had evacuated his family in time to save their lives. Then the west branch dam collapsed, sending a surge of water downstream. A warehouse containing thousands of dollars' worth of yarn and goods was knocked down "stone by stone" until it finally collapsed, sending up a plume of dust so large that onlookers feared the rubble was on fire. Its water wheel was found two miles away. Next, a three-story building and its 80 power looms vanished; its surrounding woodland was stripped bare, and the trees were replaced by a field of rocks and gravel. So much debris accumulated in the west branch that it backed up into the east branch, flooding the valley in between and

Jane Hargraves cradles her infant as her house is taken by the flood. (Mike Sharp)

leaving a thick layer of mud and silt. At its highest, the west branch of the Chester Creek reached 23 feet.

Where the west branch and east branch met, there was a three-arch bridge. As the wrecks of buildings, trees, and machinery piled up against it, it dammed the water up to a depth of 33 feet. If the bridge had given way, it might have spared the houses and mills nearby. The solidly built bridge unfortunately held fast, and as a result the rush of water found its way around the bridge and roared straight toward the Knowlton Mill and the mill village nearby. The mill had just been built using the latest construction technology, made entirely of solid stone, and stood three stories high. It was filled with brand new power looms. As the creek pulled the building apart stone by stone, the bell in the bell tower tolled ominously until it, too, came crashing down.

There was a silver lining to the catastrophe at Knowlton Mill, though—the timing. The mill employed over 50 workers, most of them female, who usually worked on Saturdays. But the major projects of the week had been completed and they'd all been dismissed early, so no one was in the mill when it was destroyed. The wreck of the Knowlton Mill was a battering ram, pummeling every mill, dam, and house downstream, traveling at an estimated 20 miles per hour. One of those houses belonged to the elderly John Rhoads, who lived with two of his grown daughters in the village of Rockdale. A third daughter lived nearby, and her daughter was visiting her grandfather at the time of the calamity. John, his two daughters, and his granddaughter all perished, leaving the girl's mother alone to mourn the loss of her entire family. John, one of his daughters, and the granddaughter were found two miles downstream. The other daughter was found near Marcus Hook, having been washed down the entire length of the Chester Creek into the Delaware River.

In a home near to that of John Rhoads, Mary Jane McGuigan drowned along with her infant child. The infant child was only discovered six months later, buried in a deposit of earth. Her mother was never found. Another neighbor of John Rhoads was Samuel Riddle, who was at work at his factory during the flood, and the second floor of his home became the refuge of 13 terrified young women. Though the house rattled, and

the women could hear the shrieks of the Rhoads and McGuigan families as they died, a large tree in front of the house took the brunt of the debris, deflecting it around the Riddle home. All 13 women survived.[7]

As the sun rose on August 6, 1843 the general emotion was shell-shocked desolation. In the following days, the discovery that the catastrophe had occurred almost entirely within Delaware County (the nearby Brandywine Creek, which was almost always the first to flood, had been minimally affected) caused people to wonder why they had been singled out. The report stated, "Our little county appears to have been destined in a peculiar manner, to bear nearly the whole brunt of the calamity. The shock was so sudden and so violent, that for a few days the people stood aghast, almost ready to believe that their county had been overwhelmed in irreparable ruin."[8] Twenty families saw their homes entirely destroyed; more than 100 other families lost their furniture, clothes, tools, and worldly possessions. The people of Delaware County quickly mobilized to care for the homeless, and donations arrived from Philadelphia and Chester to purchase the necessities for those affected, including over 400 children. Eight factories, two flour mills, three saw mills, two paper mills, and more than 20 other buildings had been obliterated. Countless others were heavily damaged. Fifty-three mill dams were destroyed, rendering those mills that still stood—which had been powered by the water flow from these dams—unusable. Thirty-two of the county's bridges were wholly or partially destroyed, disrupting transportation for years.

The most tragic legacy of that night was the loss of life. Nineteen people, most of them children and young adults, were drowned or killed by debris. That number could have been far worse, had the flooding happened at night when people were asleep in their beds, rather than in the late afternoon when the sun was still up.

The longest-lasting effect of the flooding was the almost complete destruction of farming and agriculture along the four affected creeks, as rocks, gravel, sand, and debris replaced fertile farmland. In many places it would take years for enough grass to regrow to even pasture animals. A seven-foot-wide boulder near Radnor was moved several hundred yards down Ithan Creek; millstones weighing 2,000 pounds

from mills upstream on Chester Creek were found at mills downstream. A 1,700-pound iron boiler was swept from Crozer's factory on Chester Creek and ended up lodged in a mill dam a mile away, filled with gravel and sand. A massive amount of sand and silt carried by the four creeks ended up in the Delaware River, causing concerns about needing to dredge the waterway to allow ships to reach Philadelphia.

The flood claimed its last life two days after the disaster, when ten-year-old Reuben Yarnall, Jr. of Edgmont went wading in his usual spot in the Rocky Run (a tributary of Chester Creek), only to drown when he discovered that the normally 18-inch-deep run had been excavated by the rushing water to a depth of eight feet—and he couldn't swim.

The flood of August 5, 1843 was historic and inexplicable—a fact which led the Delaware County Institute of Science to appoint a committee to conduct interviews, compile information, assess damages, and answer the big questions of *why* and *how*. Appointed to the committee were Minshall Painter of Middletown Township, a printer and avid natural scientist who with his brother Jacob founded a botanical garden that later became Tyler Arboretum. Also on the committee was John Price Crozer, a textile manufacturer whose factories had been damaged in the Chester Creek flooding (his mill was the one that lost its iron boiler). Crozer would go on to fund the Normal Institute for Boys, which later became the Crozer Theological Seminary where Martin Luther King, Jr. attained his Bachelor of Divinity degree. The final member of the committee was Dr. George Smith, a physician, state senator, and landowner in Darby who 20 years later would go on to write *The History of Delaware County*.

The committee concluded their report by blaming the ferocity of the flood on the interference of humans who built bridges and other obstacles that prevented the natural diffusion of the water over meadows and fields. Clearing timber for fields and building exacerbated the problem by essentially creating a racing strip where water could build up deadly velocity over long distances—and the danger of flooding would only get worse with time and further development. This report became one of the first American environmental warnings about the toll that human activity takes on natural meteorological events.

On August 7, 2019, almost exactly 176 years after the greatest flood in Delaware County history, a powerful storm struck the same geographical area. It started around 3pm and ended around 7pm, just like the storm in 1843. It unleashed four to eight inches of rain in those four hours and spawned several whirlwinds that whipped through Delaware County, twisting trees off midway up their trunks and leveling a straight swath of damage for several miles. Over one hundred lightning strikes were recorded along the I-95 corridor through Chester and Delaware Counties. Hundreds of residents were affected by the flash flooding and water rescues that followed, and dozens of buildings were flooded.

Many residents recalled it being the worst storm they'd seen in their lives; one man described the event in these terms: "The skies opened up and sucked in the world."[9] One can only imagine the emotions of that night almost exactly 176 years earlier—without warning, without understanding, and utterly without mercy.

Notes

1 Benjamin Franklin writing as Richard Saunders, *An Almanack For the Year of Christ 1735* (Philadelphia: B. Franklin, 1734), https://founders.archives.gov/documents/Franklin/01-02-02-0001.

2 William K. Klingaman and Nicholas P. Klingaman, *The Year Without a Summer: 1816 and the Volcano that Darkened the World and Changed History* (New York: St. Martin's Press, 2013), 89.

3 William Penn to Lord North, 1683. Quoted in Ben Gelber, *The Pennsylvania Weather Book* (New Brunswick, NJ: Rutgers University Press, 2002), 17.

4 Delaware County Institute of Science, *Report of a Committee of the Delaware County Institute of Science, on the Great Rain Storm and Flood, which Occurred in That County on the Fifth of August, 1843* (Chester, PA: Y.S. Walter, 1844), 16.

5 Ibid., 19.

6 Ibid., 41–42.

7 Ibid., 45–46.

8 Ibid., 33.

9 William Boggi quoted by Trang Do (@TrangDoCBS3), "'The skies opened up and sucked in the world. It was crazy.' William Boggi snapped a picture of a minivan teetering on the edge of a sinkhole that opened up outside of the Giant in #Broomall after last night's storms ...," Twitter post with photos, August 8, 2019, https://twitter.com/TrangDoCBS3/status/1159407055737954304.

The Saddest Song Ever Written: A Horrific Triple Murder in West Chester

It would be difficult to overestimate the social upheaval that occurred between 1900 and 1945. The turn of the century witnessed enormous advances in technology that changed the literal landscape forever, as automobiles forced the widening of roads and led motels, gas stations, and rest stops to blossom across the Pennsylvania countryside. In 1914, World War I began in Europe and not only rocked the global economy but precipitated the movements of massive amounts of troops around the world. Just as World War I drew to a close, a devastating pandemic called the Spanish Flu killed as many as 50 million people worldwide. In America in the 1920s, Prohibition made the production and sale of spirituous liquors illegal and women won the right to vote. The 1920s also saw a resurgence of the Ku Klux Klan and the emergence of the Communist Party in China, the tremors of which would shake American society to the core for decades to come.

But the signature event of the 1920s was the crash of the stock market in October 1929 that ushered in the worst economic depression of the twentieth century. When the Great Depression struck, leaving one-third of the American workforce unemployed and a further one-third on reduced hours, a sense of uncertainty crept over the nation. For a society that had been told throughout the boom years of the 1920s that an individual's self-worth correlated directly with the number of things they owned, the Depression crippled not only the American economy, but the American psyche as well. Even the shining achievements of the 1920s became tainted in the 1930s. In 1927, Charles Lindbergh made history

as the first pilot to complete a solo nonstop flight across the Atlantic Ocean, but by 1932 all anyone could talk about was the kidnapping and murder of his infant son, Charles Lindbergh, Jr. In the 1920s Americans rode high on a wave of peace and optimism for having fought and won the "War to End All Wars," but by 1933 a man named Adolf Hitler rose to power in Germany on a ticket of racism and intolerance. By 1936, he began invading nearby territories, and another bloody war hovered on the horizon.

This was the world in which Sarah Oberle found herself in 1936, and the sense of uncertainty and looming disaster would cause her to commit an unthinkable crime.

Nothing about Sarah's early life stands out as anything other than completely ordinary. She was born on April 12, 1887 to Rudolph C. and Elizabeth Barr Lukens, 15 months after their marriage in Marple Township, Delaware County. Rudolph was a carpenter, and "Lizzie" a homemaker, and together they would have at least five children.

Sarah Lukens married Joseph Shuman Oberle in 1917. Joseph had grown up on and around farms in Montgomery County, and by the time he married Sarah he had just gotten a job as the farm agent for Franklin County. A farm agent worked not only with farmers to evaluate growing patterns and help bring their products to market, but with consumers as well. A farm agent organized farm shows and competitions, conducted nutrition education programs, and generally provided a liaison between the farmer and the market, making sure that farmers were growing what consumers wanted and that consumers were purchasing the best products for their family's needs. In the 1920s and 1930s southeastern Pennsylvania was still heavily agrarian, so the position of "farm agent" was a coveted and lucrative one.

While living in Chambersburg, Sarah gave birth to her first child, a daughter named Mary Elizabeth. Three years later, Joseph was appointed as the first farm agent for Snyder County, with his salary paid through federal and state funds, and he moved his wife and daughter to Middleburg, Pennsylvania. Almost nine years after their first child, Sarah and Joseph welcomed a son named Joseph Shuman Oberle, Jr. in 1926, soon followed by another daughter, Sarah Louisa (who went by Louisa)

in 1927. In October 1929, mere weeks before the Black Tuesday stock market crash that precipitated the Great Depression, Joseph Oberle won the prestigious position of farm agent for Chester County, and the whole family moved to a rented house in West Chester.

The Great Depression hit Chester County farmers hard. As historian Derek Shugar noted, "When faced with the menace of poverty, people are forced to alter their lives in ways that will ensure their survival. Changing one's diet is often a way to reduce the costs of living."[1] The effort to reduce consumption of expensive foods often resulted in poor health and malnutrition; in March 1933, the *Daily Local News* warned its readers about the dangers of "winter anemia" and advised including seafood, greens, and cocoa into the family's weekly food budget. For local farmers, the prices of cornerstone items like grains and milk bottomed out. It was soon cheaper for people to burn corn than coal to heat their homes, and the dairy-rich farms in Chester and Delaware counties found the price of cheese dropping from 29 cents per pound to 16 cents per pound.[2] Farmers slaughtered their cows rather than face the expense of feeding them. All of this was good news for the food consumer in West Chester, but as farm agent for the county, Joseph Oberle was under a massive amount of stress to keep farms afloat.

Despite his stress, and the economic fallout around them, Joseph's job paid well and the Oberles were active members of West Chester's upper middle class. Sarah fundraised for Methodist charities, and Joseph was a popular judge at farm shows. In 1935 oldest daughter Mary, who was vivacious, intelligent, and athletic, was elected Senior Class Vice President at West Chester High School. They rented a house at 514 Sharpless Street, and according to the 1930 census were one of the 12 million American households that owned a radio. At the beginning of the 1930s, radio was an affordable way to keep up with current news, and entertainment programs like *Amos 'n' Andy, Abbott & Costello,* and *Buck Rogers in the Twenty-Fifth Century* gave Americans a small escape from the grinding worry and poverty all around them. In 1933, President Franklin Delano Roosevelt started his *Fireside Chats,* keeping Americans informed about world events and reassuring them of hope for the future.

But by 1936, *hope* was a tough sentiment for Sarah Oberle to muster. Throughout 1935, Sarah experienced a variety of ailments that puzzled her family physician, Dr. Samuel Leroy Barber. He could find nothing wrong with her, so he sent her to specialists, who also couldn't pinpoint a specific illness. Sarah, however, insisted that something was seriously wrong; her worry was so great that she lost 20 pounds in less than two months. By the end of 1935, she was convinced that she had cancer. Her father-in-law, George, told the newspapers later that she had "constantly been afraid she was going to die; she thought she didn't have long to live."[3] Adding to her stress was Joseph's decision to purchase a large old house at 411 S. Walnut Street. Joseph's job at the Farm Extension was secure, and they needed the extra space since Joseph's widowed father George would be living with them. The Oberles moved into the new house on Walnut Street just before Christmas 1935.

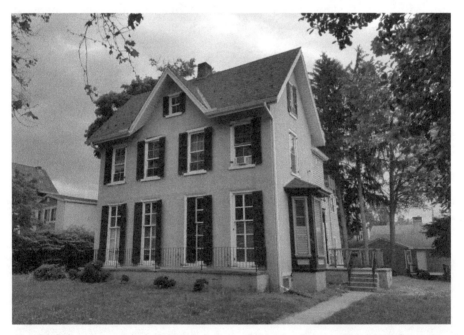

The home in which the Oberle children once lived still stands on Walnut Street in West Chester, Pennsylvania. (Author)

Sarah's emotional health spiraled in the weeks after Christmas. On the evening of January 14, 1936, Sarah complained of a splitting headache.[4] Her husband Joseph had just left for a conference in State College ahead of the annual Pennsylvania Farm Show in Harrisburg, which would be held January 20–24, 1936. As the rest of the family retired for the evening, Joseph's father George would later remark that Sarah had borne "a certain look ... that seemed to indicate things were wrong."[5]

The timeline of events that followed is uncertain, but sometime after midnight Sarah found a pinch bar (an iron tool similar to a crowbar but smaller) and went up to oldest daughter Mary's room. Mary was in bed, and either just before the first blow, or shortly after, she woke up and tried to get away, managing to get her head and shoulder off the edge of the bed. That was as far as she made it. Her skull was crushed by her mother's attack; blood spattered up the wall, cast off the pinch bar as Sarah struck her daughter over and over again. When she was sure that Mary was dead, she went to the bedroom that Joseph, Jr. shared with Louisa. The two children not only shared a room, but a bed as well, and they were both fast asleep next to each other. For whatever reason—whether the bludgeoning of Mary had been too difficult, or Sarah herself was exhausted—she fetched a knife and instead of bludgeoning her younger daughter, she stabbed her in the back, piercing the sleeping girl's heart. For Joseph Jr., she changed methods again, strangling him with the sash of her own bathrobe. Then she used the pinch bar to make sure they were dead, striking them in the heads and shoulders, and when she was done, she dropped the bar onto the floor and took the knife into the bathroom.[6]

Sketches of the three Oberle children appeared in newspaper articles across the country. Louise (7, top left), Joseph Jr. (9, top right), and Mary (17, bottom center). (*Pottstown Mercury*)

One ongoing mystery of the Oberle murders is the bathtub. Sarah at some point filled it with three feet of water, almost to the very top. Whether she initially intended to drown the smaller children before she changed her mind to bludgeoning them, or thought she would commit suicide by drowning herself, is unknown. Police later discovered towels, her bathrobe, and the knife in the bloody water. Some reporters conjectured that she was trying to clean up the blood after the murders. Dr. Barber later observed that her wristwatch had stopped at 2:30am, likely from being submerged in the bathwater.

Either before or after filling the bathtub, Sarah took the knife she'd used to kill Louisa and slashed her own wrists, abdomen, and throat. Though she bled profusely, the wounds evidently were not deep enough to kill her. Shortly before 7am she found an electrical wire, wrapped one end around a doorknob at the top of the stairs and the other end around her throat, and threw herself off the landing. The wire pulled tight and finally snapped, dumping her onto the floor below. Failing at her second (or perhaps third) attempt to commit suicide, she broke down and telephoned Dr. Barber. Sobbing bitterly into the phone, she told him to "Come right away, I've just killed them."[7]

Dr. Barber rushed to the Oberle house, about eight blocks from his own, and found Sarah on the floor at the bottom of the stairs with the broken electrical cord still wrapped around her throat. He asked where her husband was, and she replied that he was in State College. As he untied the cord, he said he would call Mary down to help him. Sarah responded "There is no Mary. I killed her. I killed all three."

Shocked, Dr. Barber ran up the stairs and discovered the gruesome scene. He checked the other rooms in the house and found that George Oberle—79 years old and almost entirely deaf—had slept through the entire tragedy. Having roused George, Dr. Barber ran outside and found a policeman named Abner Glisson making his rounds, who took Sarah Oberle into custody and rushed her to West Chester Hospital, where she was listed in critical condition due to her injuries. Dr. Barber himself conducted the autopsies on the three children; children whom he had treated for bruises and bumps and illnesses for the past six years as their family doctor.

Authorities remove one of the Oberle children from the house. Their viewing at the Harold A. Famous funeral home on Church Street in West Chester drew over 1,500 people, including many of Mary's school friends. (Getty Images)

When notified of the murders, Joseph Oberle rushed home but refused to talk to the press or see his wife. The only person who visited Sarah was her sister Marion Hart; upon seeing Marion, Sarah began babbling and the only words Marion could make out were "Where's daddy? Where's daddy?"[8]

Three days later, on Saturday, January 18, 1936, the three Oberle children were laid to rest at Arlington Cemetery in Drexel Hill, Pennsylvania, while a sanitary committee met to decide whether Sarah was insane at the time of the murders. Dr. Barber was on the panel that diagnosed Sarah as insane and not fit to stand trial, and on January 24, 1936 she was moved to the Allentown State hospital for treatment for her mental illness.

While at Allentown, doctors noted that she was often despondent, but in mid-May she'd seemed happier. On the evening of May 23, 1936, the hospital put on an entertainment, but Sarah elected to stay in her room instead of attending. When her roommates returned, she chatted amiably with them until bedtime. After everyone had

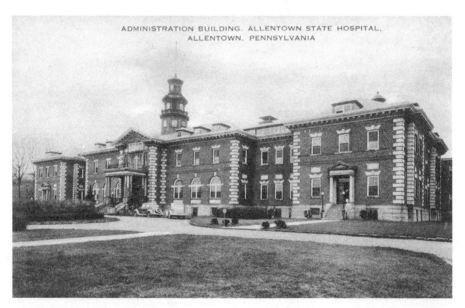

Allentown State Hospital in 1938, two years after Sarah Oberle was transferred there for treatment. (Wikimedia)

fallen asleep and the night nurse had completed her first rounds, Sarah snuck out of her room at the hospital, leaving a painstakingly realistic dummy made of blankets on the bed. She made her way out onto the sleeping porch, where patients were permitted to sleep and enjoy the cool evening breeze. From the porch, she was able to crawl through a window into the bathroom, which was typically locked at night.

The first thing that Sarah did was fill the tub with water—an eerie throwback to the night she'd murdered her children. Perhaps she had, once again, intended to end her life by drowning, and again had lost her nerve. She carefully removed her robe and nightdress and hung it on a screen and pinned a note to it that read "My husband and family are innocent of my wrong doing and have believed me insane at the time of my crime. As God is their judge, I leave everything to my husband and may God bless him." She then removed the cord of her bathrobe and secured one end to the bathroom fixture, then looped it around her throat. This time, she succeeded in ending her own life.[9]

The next morning, hospital staff discovered the dummy blankets in Sarah's bed, and found her body in the bathroom. Her remains were turned over to Coroner Alexander M. Peters, who placed her time of death at around 2am.[10] Joseph Oberle, who had only four months previously buried all three of his children, came to collect his wife and take her home. He buried her in the same plot with their three children, reserving an empty space for himself.

Just as a mother slaughtering her children today evokes the deepest kind of horror, this crime in 1936 shook the entire community. In trying to unravel the *why* of Sarah's crime, newspapers carrying the tragedy roundly blamed Sarah's "snapping" on her fear of death and the uncertainty about how her children would live without her. These were not reasons given by Sarah herself, who was reported as "deranged" and nonsensical in the days after her crime. All we know from her suicide note was that she admitted that what she'd done was wrong, and that her family *believed* her insane at the time of the murder. She never gave her own reason for doing what she did.

The Oberle family gravestone at Arlington Cemetery in Drexel Hill, Pennsylvania. The plot contains all three Oberle children, along with their parents Sarah and Joseph, and Joseph's second wife Amy Taylor Oberle, whose name is etched on the left side of the base. (Author)

In studies of maternal filicide perpetrators, there are several motives that can contribute to murder:

- Altruistic Filicide: a mother kills her child out of love, believing that death is in the child's best interest—that she is saving her child from a worse fate by taking their life.
- Acutely Psychotic Filicide: a psychotic or delirious mother may take her child's life for no logical reason, perhaps as a result of hallucinations that tell her to kill.
- Fatal Maltreatment Filicide: a mother causes the death of her child through cumulative neglect or abuse.
- Unwanted Child Filicide: a mother feels that her child is a hindrance or a burden, and decides to remove that burden through murder.

- Revenge Filicide: a mother kills her child to inflict emotional injury to the father or another family member.[11]

Based on what little we know today about Sarah's condition at the time of the murders, it seems likely that the reason for her actions was one of the first two—altruistic or psychotic. There is no evidence that she mistreated the children; on the contrary, she was widely regarded as a good mother and dedicated to her family and home. It is also equally unlikely that she murdered the children to spite Joseph, as there is no indication of marital discord. In a study of filicide published in the journal *World Psychiatry*, the researchers concluded that:

> Filicide-suicides have much in common with filicides committed by severely mentally ill mothers. Most frequently, these mothers have altruistic motives. Similar to results of other studies, our recent American study found that maternal filicide-suicide perpetrators killed older children more often than infants (mean age of children killed was 6 years old). The mothers often had evidence of depression or psychosis. These mothers often take the lives of all their young children.[12]

Sadly, Sarah Oberle was far from the first—or last—mother to commit filicide. On March 20, 1888, in Philadelphia, 40-year-old Sarah Jane Whiteling reported the death of her husband John; the family doctor determined that the cause was "inflammation of the bowels." A month later on April 25, 1888, Sarah's nine-year-old daughter Bertha died of "gastric fever." A month after that, on May 26, 1888, two-year-old Willie died. The family doctor, George Smith, finally felt that the incidents were suspicious enough to alert the authorities. When their bodies were exhumed, large amounts of arsenic were found in all three. The local drugstore clerk told the police that Sarah Whiteling had purchased a box of *Rough on Rats*, a pesticide and insecticide containing arsenic, around the time that her husband fell ill.

The press immediately went on the attack, calling Sarah Whiteling a "female fiend," "modern Borgia," and "harlot." The front page story of the *New York Times* on June 13, 1888, cried out that "The woman's crimes, which will rank in conception and execution with the most diabolical murders on record, appear to have been committed for the

pitiful sums of money for which the victims' lives were insured."[13] During her inquest, Sarah Whiteling mentioned that the family was poor and owed money to everyone, and that the insurance money she got from John's death only lasted "a little while and then I thought what was placed on Bertha's life ..."[14] That Whiteling had committed filicide was not in dispute—the question was whether she was insane at the time. When the newspapers latched onto the insurance money angle, even though the insurance payouts were ridiculously low, her actions seemed less insane/altruistic and more greedy and premeditated. The fact that so much time elapsed between the murders also looked premeditated. After a two-hour deliberation, a jury found her guilty of murder, and she was sentenced to hang.

One of Sarah Whiteling's most vocal advocates was Dr. Alice Bennett, the first woman to hold the position of Resident Physician of a women's division in a state hospital. Hired by Norristown State Hospital as the first female head doctor for female patients, she quickly made a name for herself by fighting against the use of physical restraints in psychiatric institutions. After interviewing Whiteling extensively, Dr. Bennett put forth an interesting new psychological argument—a mental breakdown brought on by physical illness. She testified that Sarah Whiteling had for years suffered severe menstrual symptoms like pain, dizziness, and disability, and when her husband became ill in February 1888 she suddenly had to care for both a husband and her children for four weeks with little to no income and no hope for the future. Dr. Bennett argued that Sarah was "'nearly wild' with the strain upon her. At this time, her menstrual period was due and did not appear, and the fear that she was pregnant aggravated her mental strain."[15] Feeling trapped and presented with the thought of an additional mouth to feed, she poisoned her husband and collected his paltry $145.00 insurance payout ($60 of which went directly to paying for his burial). Dr. Bennett argued that the timing of the other two murders—each almost exactly one month after the last—coincided with another missed period and fears of pregnancy or some terrible disease. Whiteling confessed that she had reserved a dose of arsenic for herself, but never took it; in an act later viewed as a form of "judicial

suicide," she refused to support any efforts from her defense team to secure a stay of execution. She told her attorney "Let me die. Don't spend any more money, nor waste any more time on my behalf. Let the matter rest where it is."[16] Sarah Whiteling's execution took place on June 25, 1889; she was buried next to her family at the Mechanicsburg Cemetery in Cumberland County, Pennsylvania.

When Dr. Bennett argued that Sarah Whiteling killed her children out of fear for the future, she was lambasted by a hostile press. Decades later, the newspapers treated Sarah Oberle very differently. Sarah Whiteling

Dr. Alice Bennett, the first female superintendent of the women's section of the Norristown State Hospital from 1880–1896. She was a strong advocate for the humane treatment of patients. (Wikimedia)

was poor, the daughter of German immigrants; Sarah Oberle was solidly upper middle class and from a respectable family. The thread of fear of the future and a crushing sense of responsibility for the family's well-being are woven through both stories. Dr. Bennett argued that early identification of these stresses in families could prevent such tragedies in the future, but the stigma of mental illness prevented many women from seeking treatment. Late-nineteenth-century society—especially middle- and upper-class society—clung to the idea that mental illness was indicative of a genetic failing. As historian Andrew Scull observed:

> The very language used to refer to those suffering from madness is indicative of the harshness with which they were viewed. A British psychiatrist lamented that degenerates were born every year "with pedigrees that would condemn puppies to [drowning in] the horsepond." The mentally ill were referred to as

"tainted persons," "lepers," "moral refuse," "ten times more vicious and noxious, and infinitely less capable of improvement, than the savages of primitive barbarism," and endowed with "special repulsive characters"—and this by the very people who claimed to be in the business of treating them.[17]

Sarah Oberle had grown up in an age where mental illness was seen as a defect that required stamping out; according to the standards of her day, she might never have been permitted to marry or have children if she had received such a diagnosis. In 1883, Francis Galton first used the term "eugenics" to describe the "scientific" idea that superior genetics led to more successful and beneficial members of society. By the first decades of the twentieth century, a network of scientists and so-called social reformers blamed the world's ills on the "inferior" genes of certain easily identified segments of the human population. Blacks, Jews, gypsies, and eastern Europeans fell into these categories, but the primary targets were the insane and the disabled. By the 1890s, Norristown State Hospital was already sterilizing its female patients ostensibly to cure their "hysteria," but also to prevent mental illness from being passed to the next generation. By 1907, forced sterilization was codified into Indiana state law as it became the first of 30 states to mandate compulsory sterilization for the less "desirable" members of society. Opponents argued that the right to procreate was protected under constitutional law, and it was widely seen as an abuse of human rights, but the United States Supreme Court upheld the law. To this day, the forced sterilization of patients in mental health facilities has never been officially ruled unconstitutional.

Recognition of the special mental and emotional strain that childbirth and childcare place on mothers has only been explored and publicly addressed in the past few decades. As recently as January 2021, an American mother named Oreanna Myers shot all five of her children in the head with a shotgun, set their house on fire, then turned the gun on herself. In her suicide note she wrote, "I hope one day someone will help others like me. Mental health is not to joke about or taken lightly. When someone begs, pleads, cries out for help, please help them. You just might save a life or more lives."

In another note, Myers wrote, "This is no one's fault but my own. My demons won over me, and there's no going back. So sorry I wasn't strong enough."[18]

For the Oberle family, the only choice was to somehow move on. Joseph S. Oberle, Sr. stayed in the house at 411 S. Walnut Street with his father after the murders. He continued working as a Chester County farm agent, and finally retired in 1951. He married a woman named Amy Taylor, and moved to Dilworthtown, but they had no children together. Joseph died on September 24, 1969 at Paoli Hospital after a short illness, and was buried with his first wife and three children at Arlington Cemetery. In 1985, his second wife Amy Taylor Oberle joined them there.

Though all but forgotten in the history of West Chester, the tragic tale of the Oberle children may have been memorialized in an unexpected way. One of the most celebrated classical musicians of the twentieth century was Samuel Barber, who was born in 1910 in West Chester. If the last name Barber rings a bell, he was the son of Dr. Leroy Barber—the Oberle family physician who discovered the bodies of the children and diagnosed Sarah Oberle as insane. The Barbers, like the Oberles, were a financially comfortable and well-educated family, moving in the same social circles. Samuel Barber's maternal aunt was Louise Homer, a leading contralto for the Metropolitan Opera, and his uncle was Sidney Homer, a composer, so music was in Samuel Barber's blood. He wrote his first composition at age ten and attended West Chester High School where young Mary Oberle would so briefly serve as senior class vice president, and even wrote the high school's alma mater, which is still in use today. Barber graduated in 1928, just four years before Mary Oberle began attending classes there. In 1936 he was studying music in Vienna when he found out about the deaths of the Oberle children and Sarah's suicide four months later. In the summer of that year, Samuel Barber composed *Adagio for Strings*, which is now largely regarded as the saddest classical work ever written. Mourners have heard it played for Albert Einstein, Princess Grace, Franklin D. Roosevelt, and John F. Kennedy. It has become the signature music for

events honoring the victims of mass murder, from the September 11, 2001 attacks in New York, to the 2015 massacre of staff of the French magazine *Charlie Hebdo,* to the 2016 Pulse nightclub shooting, and the 2017 Manchester Arena bombing. It has even been played for the victims of the coronavirus pandemic, which at the time of this writing is still ongoing. Though Barber attributed Virgil's *Georgics* as his inspiration for the piece, the tragedy of the Oberle family could not have been far from his mind that summer, and *Adagio for Strings* has since become the mournful requiem to victims of senseless murder across the world.

Notes

1 Derek Shugar, "Diets in West Chester During the Great Depression," *West Chester University Digital Commons* (2006), 1–5. http://digitalcommons.wcupa.edu/hist_wchest/79.

2 Ibid., 2.

3 "Deranged Mother Kills 3 Children at West Chester," *Intelligencer Journal* (Lancaster, PA), January 16, 1936, 14.

4 "Mother, Slayer of Three, Will Get Sanity Test," *The Evening News* (Harrisburg, PA), January 17, 1936, 13.

5 "3 Children Slain by Mother Who Attempts Suicide," *The Morning News* (Wilmington, DE), January 16, 1936, 1, 17.

6 Ibid., 17.

7 "Deranged Mother Kills 3 Children at West Chester," 1.

8 "Imagined Ills Drove Mother to Slay Three," *Public Opinion* (Chambersburg, PA), January 16, 1936, 1, 9.

9 "Slayer of Her Three Children Ends Life Here," *The Morning Call* (Allentown, PA), May 24, 1936, 6, 12.

10 Ibid., 12.

11 Susan Hatters Friedman and Phillip J. Resnick, "Child murder by mothers: patterns and prevention," *World Psychiatry* 6, no. 3 (October 2007), 137–141, https://www.ncbi.nlm.nih.gov/pmc/articles/PMC2174580/.

12 Ibid.

13 Kenneth J. Weiss, MD, "Arsenic, Familicide, and Female Physiology in Nineteenth-Century America," *Journal of the American Academy of Psychiatry and the Law* 48, no. 3, May 13, 2020, 386.

14 Ibid., 386.

15 Ibid., 389.

16 Ibid., 388.

17 Andrew Scull, *Madness in Civilization* (Princeton and Oxford: Princeton University Press, 2015), 265.

18 Joseph Wilkinson, "West Virginia Mom Fatally Shot 5 Kids, Burned Down House, Then Died by Suicide: 'My Demons Won Over Me,'" *New York Daily News*, January 22, 2021. https://www.nydailynews.com/news/national/ny-west-virginia-mom-murder-kids-burn-house-20210122-bl7fy4tnpvax5ohupa535z3fke-story.html.

Fire From Within: The Strange Case of Helen Conway

The most cursory of glances at the Merriam-Webster definition of "fire" instantly illustrates the role which the element has taken in our lives. While it is scientifically defined as "the phenomenon of combustion manifested in light, flame, and heat," it has also carved out an emotional niche for humans. *Fire* can be a burning passion for someone; it can represent brilliance or luminosity; it can paradoxically stand for both an all-consuming anger and bubbling enthusiasm.[1] Fire can warm your hands or destroy your house. Fire preserves us and consumes us. And sometimes, it consumes from within.

It has happened often enough that we've given it a name—*spontaneous human combustion*. SHC is loosely defined as the destruction by fire of a living or recently deceased human body without any source of ignition such as matches, open flame, or electrical current. SHC remains one of the longest-running phenomena to evade concrete scientific explanation despite countless attempts to explain and debunk it. How, after all, does a human body composed of up to 70% water burn away to nothing but ash without being set alight by any identifiable source?

Though it's reasonable to assume that mysterious human deaths by fire have occurred for millennia, one of the first documented cases of possible SHC took place in Dorset, England in 1613. On June 26 of that year, a carpenter named John Hittchell, his wife and child, and his mother-in-law Agnes Russell all retired to bed for the evening, while an electrical storm raged outside. Agnes later awoke to a blow on her cheek and cried out for help, but her daughter and son-in-law didn't respond.

She scrambled over to their bed only to find her daughter burnt down one side and the child and Mr. Hittchell dead beside her. Mr. Hittchell's body felt burning hot to the touch, although there was no sign of flames. They dragged him out into the street, where he continued to smolder for three days, still with no visible fire but with smoke emitting from his body.[2] The fact that John Hittchell was reduced to ashes over three days isn't the weird part here—the fact that the fire remained entirely *inside* of his body was what scared people.

Another well documented case of suspected SHC occurred a century later, across the English Channel. In 1725, in the northeastern French town of Reims we find a report by an apprentice surgeon named Claude-Nicolas Le Cat in which he recalled the death of Jeanne LeMaire (sometimes called Nicole Millet), an innkeeper and notoriously bad-tempered alcoholic who arose from her bed late one night to warm herself by the hearth fire. Her husband Jean Millet awoke later to the smell of something strange and, thinking the inn was on fire, screamed an alarm for everyone to wake up. Among the lodgers that night was the curious Le Cat, who sought the source of the odd smell and discovered Madame LeMaire in the kitchen. Her body—what was left of it—lay on the floor near the fireplace. Only part of her head, a portion of her legs, and a few vertebrae survived what had surely been a white-hot blaze. The floor under her body had burned, but a wooden dough trough near the body was undamaged. When pressed for an explanation, Le Cat could only ascribe the death to "the visitation of God."[3] Authorities accused Jean Millet of murdering his wife and the case went to court, during which Le Cat testified for the defense and laid out his thoughts about spontaneous human combustion. Later, when Le Cat developed a reputation as a respected surgeon, he published his memoir in which he repeated his assertion that the unfortunate innkeeper's wife fell victim to SHC.

Six years later and 750 miles southeast of Reims, another notorious case occurred. In 1731 in Cesena, a city in east-central Italy, the Countess Cornelia Bandi retired for the evening after reporting to her maid that she felt unwell. At suppertime she had started feeling "dull and heavy," but after going to bed she stayed up for three hours chatting with her

maid before falling asleep. The following morning the maid found her 62-year-old employer's remains on the floor four feet from the bed, burnt to ashes except for part of the head and both legs from the knees down. Bizarrely, both legs were still encased in their stockings, although everything above the knee was reduced to ash. Witnesses reported that a yellowish grease coated all of the surfaces in the room, and in fact had crept into the chest of drawers and was absorbed by the linens inside. As is typical of SHC, the furnishings including the bedsheets and curtains were basically unharmed. If bedsheets soaked in human fat isn't a strong enough mental picture for you, Rev. Giuseppe Bianchini provided this visual: "from the lower part of the windows trickled down a greasy, loathsome, yellowish liquor, and thereabout they smelt a stink without knowing of what."[4]

To the modern reader it can often be difficult to believe the reports of a superstitious age, before rigorous scientific investigation, photography, and advanced technology. Fortunately—or unfortunately—SHC didn't stop with the advent of cameras and forensic labs, as the next famous case shows. On a brutally hot and humid day in July 1951 in St. Petersburg, Florida, landlord Pansy Carpenter arrived at the door of tenant Mary Reeser's small apartment with a telegram. The landlord discovered that the doorknob was hot and screamed for help, drawing the attention of two painters working across the street. The two men broke down Mary's door, which released a blast of hot air. One of the men peeked inside the apartment and immediately told Pansy Carpenter to alert the fire department. Upon arriving at the scene, firemen and police found Mary's remains still in her easy chair. The damage seemed to have been restricted to the chair, of which only two springs remained; an end table, of which only small pieces of two legs remained; and of course, to Mrs. Reeser herself. A 67-year-old, 170-pound woman had been reduced to a few teeth, a charred liver attached to a small piece of spine, part of a hip bone, and a left foot—still encased in a black satin slipper. Some narratives include that part of her skull was found eerily shrunken down to teacup size, though no skull was ever mentioned in the original FBI laboratory report. With no real evidence to go on, investigators did their best to solve the mystery. Mary Reeser was plump, and an avid

smoker. Police later determined that the likely cause of her body's utter destruction was a dropped cigarette igniting her rayon nightgown. But how to explain such complete destruction in such a short amount of time? Some pointed to the fact that she was overweight—that her own body fat might have fueled the fire to a hotter intensity.[5]

While the Hittchell, LeMaire, Bandi, and Reeser cases are some of the most famous, they also illustrate four different theories of what actually causes ignition in such situations, and what might contribute to the unusually destructive heat involved. In the Hittchell case, it was noted that an intense electrical storm passed through the area the night that the fires occurred. An excess of electricity in the environment or within the body has often been pointed out as a possible ignition source. It's common scientific knowledge that the human body operates largely via electrical stimuli, and some animals—like eels—can use and direct those electrical fields in order to stun prey.[6] Some scientists wonder if select people might store more electricity in their bodies naturally than others, and if it's not discharged regularly—by grounding oneself—then perhaps it could build up to such an extent that it causes a spark.

Another theory postulates that rogue lightning strikes might be at fault, as between 100 and 150 people are struck by lightning in the United States alone every year and an average of 49 of those struck will die. But could a lightning strike explain the deaths of the Hittchell family? As Jenny Randles and Peter Hough noted in their book *Spontaneous Human Combustion*, most people killed by lightning strikes are not hit directly—a tree struck by lightning usually redirects that energy through the ground and into the bodies of anyone standing nearby. Could lightning have struck the Hittchell house and traveled into their bodies, causing something within them to burn? While most lightning strikes kill by paralyzing the central nervous system (not by causing widespread burns), electricity in the environment can wreak all sorts of havoc in unexpected ways. On a summer day near the turn of the century, an entire crew of sailors learned just how inscrutable electricity could be.

On August 1, 1904, newspapers across the United States reported the strange experience of the crew of the British ship *Mohican*. The ship was just entering the Delaware breakwater on its way to the port of

Philadelphia when crew members spotted an eerie gray cloud forming at a distance. In a short time, it enveloped the ship, giving the vessel what the captain described as "a fiery coating" that caused panic among the crew. The glowing fiery fog was so thick that no one could see beyond the deck of the ship. The captain noted that the needle of the compass was "flying around like an electric fan," and he ordered the terrified sailors to start moving some of the iron chains on the deck, thinking that it might distract them from the horror of the situation. It was at that moment that the captain and crew realized that the entire ship had been magnetized—all of the iron chains, spikes, and nails on the deck were stuck fast. The sailors later reported that the hair on their heads and beards stuck out "like bristles" and they could only move their arms and legs with extreme difficulty. Just as quickly as it had arrived, the phosphorescent cloud moved off into the distance, freeing the sailors and ship to continue their journey to Philadelphia.[7] To this day, the exact nature of what paralyzed the *Mohican* remains unexplained.

The *Mohican* had unknowingly sailed into one of the most electrically charged days in the Philadelphia area's history. On July 30, 1904, the *Philadelphia Inquirer* noted the unusual activity in southern New Jersey, near the mouth of the Delaware River not far from where the Mohican encountered the mysterious cloud. In Pitman Grove, New Jersey, a woman and two cows were struck by lightning in separate incidents (the woman lived; the cows did not). In Sewell, New Jersey, a bolt of lightning reportedly entered the window of a store and struck a barrel of molasses. In Burlington, New Jersey, a man was knocked unconscious when lightning struck the tree under which he was sheltering, and in Glassboro another man suffered the same fate. Both lived. In Hammonton, lightning tore out the switchboard of the electric light station and struck both a house and a local hotel. Nearby, a brick kiln was struck, and several people were injured by flying bricks.[8] A similar bout of storms moved west into Ohio and north into New York, causing immense damage in both states.

Though witnesses took note of the extraordinary lightning in the Hittchell case, it did not make an appearance in the other three cases I've mentioned thus far. In the gruesome case of Countess Cornelia

Bandi, however, another theory surfaces—that her digestive tract might have provided the flammable gases needed to fuel her combustion. Despite feeling well all day, the Countess began feeling "heavy and dull" at dinner. Rev. Giuseppe Bianchini, who provided us the earlier mental picture of human grease running down the windowpanes, later concluded that Countess Bandi had "burnt to ashes while standing, as her skull was fallen perpendicular between her legs." Author Larry E. Arnold hypothesized that the Countess, feeling unwell after dinner, may have gotten out of bed to throw up and instead vomited flames that then devoured her entire body.[9] Sound farfetched? Well, it's surprising—and frankly concerning—how much flammable gas the human body creates every day.

During the decomposition of vegetable matter, gases like methane and phosphine are produced. When this occurs outdoors, as in marshy areas, phenomena called "Will o' the Wisp" can occur as these gases oxidize and produce bioluminescence. Some argue that a similar reaction could occur within the body, in which the energy within the gut is somehow transformed into heat so intense that it can ignite the fatty tissues nearby.[10] It is noted, over and over, that many cases of suspected SHC occur in men and women who are obese and had a reputation for overeating, thus setting the scene for the possible production of a dangerous amount of digestive gas and abundant supply of body fat to burn. Even if the gases in the intestinal tract don't reach the flashover point on their own, it has been proven time and again (especially at college parties, I imagine) that flatulence escaping the body is flammable when placed near an external source of heat. Could the Countess Bandi's bodily gases have ignited due to a nearby candle and set her aflame in that way?

Overeating has, for most of human history, been frowned upon. The death of Jeanne LeMaire, with her reputation as a mean drunk, exposed another cultural stigma—intemperance. Many of us in the twenty-first century will have a drink now and then, but in the eighteenth century alcoholic beverages were much more a part of everyday life. Beer, wine, and hard cider were regular parts of most meals, and farmers often distilled their grains into hard liquor as a way of preserving them. Many accounts of SHC emerging during the nineteenth century seem

to home in on the fact that the victim may have been an alcoholic, or if not a habitual drinker, may have consumed a large amount of alcohol around the time of their incineration. One of the first medical men to propose the connection of SHC with alcohol was none other than Claude-Nicolas Le Cat, the apprentice surgeon who'd discovered Jeanne LeMaire's body. Historian Meghan Roberts noted that in his memoirs, Le Cat "took the opportunity to expound his theories about spontaneous human combustion. He linked the phenomenon to two factors in particular: excessive alcohol consumption and a sedentary lifestyle, or idleness, to put it another way—both qualities ascribed to Jeanne LeMaire." The LeMaire case exposed a cultural shift away from fear of the supernatural and toward an age ruled by medical and scientific men. "In earlier centuries, such a fiery and grisly occurrence would have suggested divine justice or demonic possession. By the mid-eighteenth century, however, it had been secularized, with no mention of God or religion from Le Cat or any other eighteenth-century scholar who addressed the issue of spontaneous human combustion."[11] Essentially, because Jeanne LeMaire was seen as a lazy drunk, she had contributed to her own demise by her poor behavior. She then became a warning to others—women especially—to avoid such indolence or risk a similar fate.

But exactly *how* did learned men in the eighteenth century believe alcohol abuse contributed to spontaneous human combustion? Given that liquors are highly flammable in their natural state, it was thought that somehow, through years of abuse, the volatile nature of spirituous liquors might be absorbed through the body and into the skin and organs. This would result in men and women that were so highly combustible that merely brushing a candle flame or electrical current could be enough to ignite them. If Jeanne LeMaire's pickled anatomy was set aflame by such methods—and for that matter if Countess Bandi caught fire due to breaking wind or burping near an open flame—these two women would no longer represent *spontaneous human combustion*, since the ignition source would be obvious—the candle in Bandi's case and hearth fire in LeMaire's. Instead, they would be reclassified as *preternatural combustion*, which is surely weird and unusual but explainable. Scientists in the eighteenth

and nineteenth century liked being able to explain the inexplicable, and if there was a moral lesson involved at the same time, all the better.

Not every nineteenth-century scientist was on board with the alcohol theory. One man, Baron J. von Liebig, had proven through experiments (the details of which are probably better left unexplored) that flesh saturated in alcohol was *not* combustible and that the corpses of drunks were no more flammable than others. A further test involved injecting rats with alcohol over long periods of time and then setting them on fire.[12]

Through the first part of this chapter, we have delved into some of the most famous cases of spontaneous human combustion and attempted to use prevailing scientific theories to debunk or at least try to explain what might have happened. All of the explanations and justifications fail, though, in the face of what might be the single most mysterious case of SHC so far. In the case of Helen Conway of Delaware County, none of the current theories seems to stand up to the evidence at hand, and that is because of one simple factor—*time*. No matter what the supposed cause of incineration might be, most scientists agree that it takes hours for a body to reduce to mere ashes. Even in modern crematories, where technology has been perfected over millennia to render a human being down to its most component carbon-based bits in the shortest amount of time, it still takes temperatures of 1,700–2,200 degrees over the span of several hours. And even then, bones remain (these will be placed into a tumbler with steel balls to break them down into powder). While John Hittchell took three days to burn completely, and Mary Reeser's remains may have smoldered for up to 12 hours, Helen Conway met her end in less than 21 minutes—and possibly as few as *six minutes*.

The leading historical authority on the death of Helen Conway is author Larry E. Arnold, and much of what we know about her came from his investigation into what had been an almost completely unknown case. Helen Ann Conway lived at 527 Argyle Road in Drexel Hill, Pennsylvania, in a large home in a good suburban neighborhood. Her husband, Stanley, had passed away in 1950, leaving Helen ownership of the Gillon Company, Inc., a rubber manufacturer in Philadelphia. They had one daughter, Marjorie Conway Verna, who with her husband James had two children named Steffany and Paul.

Helen Conway's house still stands in Upper Darby, Pennsylvania. (Author)

Until January 24, 1964 Helen had lived with her elderly mother, Helen Hesson, but the elder Helen had passed from cerebral arteriosclerosis (hardening of the walls and arteries in the brain) and was buried at Calvary Cemetery in Montgomery County. In November 1964, Helen lived with her sister, Mary Hesson, and was regularly visited by her daughter, who lived nearby, and her two grandchildren. By all accounts they were a close and loving family.

On the brisk and sunny morning of November 8, 1964, the Upper Darby Fire Department received a call for a house fire in nearby Drexel Hill. A key witness to what happened next was Robert Meslin, who at the time was an Upper Darby volunteer firefighter and later went on to serve as the department's fire marshal. In interviews recounted in Larry E. Arnold's book *ABLAZE!*, he reported the following experience:

> Upon arrival ... we found a considerable amount of smoke on the second floor which necessitated crawling on hands and knees. Firemen encountered a closed bedroom door and upon opening the door, heavy smoke and heat was encountered but little flames, save for some fire in a corner of the room to the right of the door (which was handled by a booster [high pressure water] line).[13]

Meslin recalled that an assistant chief went in on hands and knees to find Mrs. Conway, and in his search accidentally sunk his hand into something greasy, which turned out to be Mrs. Conway's remains. What firefighters viewed in that room was similar in many ways to other cases we've covered in this chapter. The easy chair that Helen had been sitting in was severely burned, especially the backrest which had completely opened up, causing Mrs. Conway's remains to fall through. Two small tables to either side of the chair were slightly damaged. The carpet directly under the chair was charred from ashes falling down from the chair, and the baseboard behind the chair was blistered. Beyond that, there wasn't much damage to the room. The damage to Mrs. Conway, however, was significant. Meslin reported that he could see her ribcage and her upper right arm. The bones of her left arm were fully exposed, but in an unsettling twist,

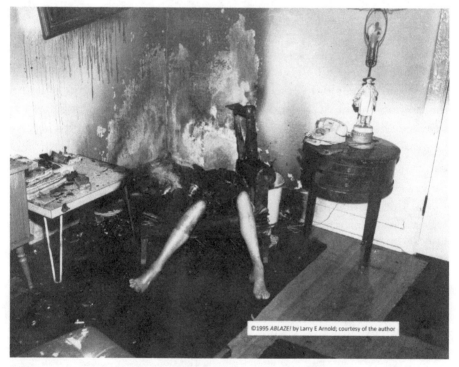

©1995 *ABLAZE!* by Larry E Arnold; courtesy of the author

The fire fatality photograph of Helen A. Conway in her sitting room on November 8, 1964, taken by Robert Meslin. ©1995 *ABLAZE!* by Larry E Arnold; courtesy of the author. (Larry Arnold)

the charm bracelet she wore on that wrist was still intact (and would later be used to identify her remains).[14] Similar to many other suspected cases of SHC, her lower legs were largely intact, still leaning against the front of her chair as though waiting for her to arise.

The authorities began their investigation into what might have caused such total destruction, but many of their possible theories were confounded by one fact—that Helen's granddaughter Steffany had seen her grandmother just before the fire started, having run to fetch Helen a cigarette. Helen was an avid smoker, which as we've seen before has been deemed the cause of SHC fires in the past, but as we shall see this theory doesn't hold up in the face of the time frame involved. You see, Steffany had either completed her task of fetching the cigarette, or discovered the fire upon returning with the cigarette, but either way you slice the timeline Helen would have been on fire for, at most, 21 minutes.

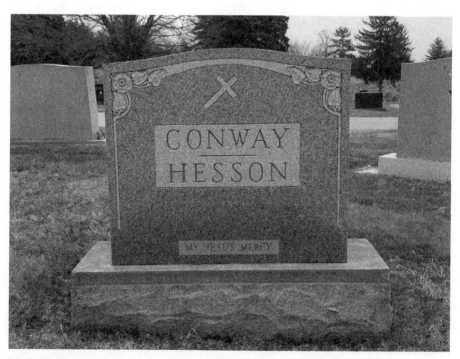

Helen Conway's grave in Calvary Cemetery in West Conshohocken, Pennsylvania. With her are buried her mother, Helen C. Hesson, and her husband, Stanley P. Conway. (Author)

Steffany reportedly discovered the fire a mere three minutes after last speaking with her grandmother and called the fire department at 8:45am. The firemen reached the scene within minutes of receiving the call.[15] In the case of Helen Conway, there was no lightning; no alcohol; she was slender, not obese; and the chances that a cigarette caused a blaze that fast are impossibly miniscule. In essence, Helen Conway defies all scientific explanation.

That didn't mean that the fire department and the coroners didn't try. Newspaper articles carried the investigators' judgment that careless use of a lit cigarette caused the fire. Helen Conway's death certificate lists the cause of her demise as "3° Burns (90%) of body" which judging by the pictures of the scene, taken by Meslin and included in Arnold's book *ABLAZE!*, seems like an understatement of monstrous proportions. In the photograph, only her legs are intact—the rest is charred beyond recognition.

In medicine there are three commonly used "degrees" of burn, but a fourth and fifth degrees are sometimes referenced. They go as follows:

- **First-degree burns:** Affecting only the outer layer of skin, called the epidermis. A first-degree burn is red, painful, and dry, but not blistered. Mild sunburn would be one example.
- **Second-degree burns:** The epidermis is burned along with part of the lower layer of skin, called the dermis. Second degree burns are red and blistered and may swell. They are very painful.
- **Third-degree burns**: A third-degree burn destroys both the epidermis and dermis and likely goes into the subcutaneous fatty tissue underneath. A third-degree burn looks blackened or charred, and skin may not be able to grow back after the injury without surgical intervention like a skin graft. These burns can be very painful, but if the burn affects the nerve endings pain might not be felt right away.
- **Fourth-degree burns:** These burns go through both layers of skin, the underlying fatty tissue, and may possibly affect muscles and bones. Nerve endings would be destroyed, which would prevent pain.

- **Fifth- and sixth-degreeburns**: These burns are catastrophic. A fifth-degree burn destroys muscle, and a sixth-degree burn will go down to the bone.[16]

Based on the list above, it's clear that most of Helen Conway's body suffered fifth- and sixth-degree burns. Perhaps in 1964 the man issuing her death certificate didn't use a classification above third-degree, and without the photos that Robert Meslin took, and his reports of the incident, we would not have been able to deduce the extremity of the event from the historical record as it stands today. The report conducted by the Upper Darby fire department was lost in a move, and the Delaware County coroner is not under obligation to release any autopsy findings or photographs to the public. This is perhaps why the case of Helen Conway did not gain much traction until Arnold conducted his research.

Even in our current technological age, when serial killers can be tracked down decades after their crimes using DNA uploaded onto the internet by a distant family member, possible cases of SHC continue to baffle investigators. In the early morning hours of December 22, 2010, a neighbor of Michael Faherty in County Galway, Ireland, was roused from bed by his smoke alarm. He spotted smoke coming from Faherty's house, but couldn't get any response from within so he called the fire brigade. Faherty's body was found lying with his head close to the fireplace; only his body, the ceiling above him and the floor below him were damaged. There had been a fire in the fireplace, but investigators determined that it was not responsible for the extensive damage that Faherty's body sustained. With surprising candor, the medical examiner in Faherty's case stated what many of his predecessors might have felt, but which few wished to have as public record: "This fire was thoroughly investigated and I'm left with the conclusion that this fits into the category of spontaneous human combustion, for which there is no adequate explanation."[17] Unfortunately, no further information from the medical examiner or other officials has been forthcoming, so the Faherty case remains difficult to pin down as a true case of spontaneous human combustion.

With SHC, there are two distinct questions that remain unanswered. First is the question of ignition. The very words *spontaneous*

human combustion indicate that the heat reaction is completely—well, spontaneous. There is no other source of ignition. So, one question that needs to be asked in every suspected case is whether or not there is a possible ignition source present. In some, like the cases of Mary Reeser and Helen Conway, the ignition source was proposed to be the cigarettes they were known to smoke. In the case of Countess Cornelia Bandi, the lit candles in her room were a possibility. For Michael Faherty, the open flames of his fireplace provided an obvious source of ignition.

The second question, though, is the most difficult to answer: *how?* How does a human body sitting in a living room chair disintegrate so rapidly, and so completely, when the most efficient crematoria cannot accomplish the same level of destruction under completely ideal circumstances? How, in the case of Helen Conway, was it accomplished in under 21 minutes? If we are, as the aliens in *Star Trek: The Next Generation* observed, "ugly bags of mostly water," what chemical and physical forces do we not yet understand about ourselves?[18]

For those wondering, SHC does not always result in death. There have been many peculiar incidents in which the victim—with or without lasting injury—survived the encounter. Dead men may tell no tales, but survivors can, and do. In a well-known incident, a man named Jack Angel went to sleep in his motorhome in Savannah, Georgia on November 12, 1974 and woke up four days later with his entire right hand burned black. In addition to the damage to his hand, he had burn spots on his chest, legs, groin, and back. The burns to Jack Angel's hand and lower forearm were so severe that he required amputation. Inspections of the motorhome could find no signs of damage to any of the furnishings; no short circuits, lightning strikes, or overhead power lines could be tied to the incident. Even the complete dismantling of the vehicle shed no light on the strange cause of the injury. Even the nature of the burns themselves was a matter for debate; his doctors claimed they looked like electrical burns, while a maintenance man insisted that the burn looked like scalding from contact with hot water or steam. Since Angel's lawyers had no better explanation, scalding was the theory they ran with when they took the case to court to claim faulty engineering in the motorhome.

Just a week before the case went to trial, it was withdrawn. The case has provoked furious speculation ever since.[19]

Some people put spontaneous human combustion into the same category as ghosts, Area 51, and the Loch Ness Monster, but this is neither accurate nor fair. None of the theories proposed by SHC supporters suggests that the answer is mystical or paranormal; on the contrary, most insist that there is a reasonable scientific explanation. As any scientist can attest—whether they look into the heavens to find new stars, into the ocean depths to discover new species of fish, or into the human body to chart its awesome complexity—there is much we do not understand about the universe around us.

Yet.

Notes

1 *Merriam-Webster Dictionary,* https://www.merriam-webster.com/dictionary/fire, consulted on March 11, 2021.

2 Jenny Randles and Peter Hough, *Spontaneous Human Combustion* (New York: Barnes and Noble Books, 1992), 187–188.

3 Larry E. Arnold, *The Mysterious Fires of Ablaze! Spontaneous Human Combustion* (New York: M. Evans and Company, Inc., 1995), 21–22.

4 Randles & Hough, 17–18.

5 Ibid., 42–63.

6 Ibid., 123.

7 "Steamship Encounters Strange Phenomenon," *The Gazette,* (Cedar Rapids, Iowa). August 1, 1904, 1.

8 "Lightning Busy in South Jersey," *The Philadelphia Inquirer,* Philadelphia, PA. July 30, 1904, 3.

9 Arnold, 24.

10 Randles and Hough, 116.

11 Tom Porter, "Spontaneous Human Combustion and the Enlightenment," January 7, 2019, https://www.bowdoin.edu/news/2019/01/spontaneous-human-combustion-and-the-enlightenment.html.

12 Randles and Hough, 25.

13 Arnold, 380.

14 Ibid., 380–381.

15 Ibid., 382–383.

16 "Burns," National Institute of General Medical Sciences, last reviewed on July 13, 2020, https://www.nigms.nih.gov/education/fact-sheets/Pages/burns.aspx.

17 Josie Ensor, "Irish Pensioner 'Died of Spontaneous Human Combustion,'" *The Telegraph*, September 22, 2011, https://www.telegraph.co.uk/news/worldnews/europe/ireland/8783929/Irish-pensioner-died-of-spontaneous-human-combustion.html.

18 *Star Trek: The Next Generation*, Season 1, Episode 18, "Home Soil," Teleplay by Robert Sabaroff. Premiered February 22, 1988.

19 Ibid., 102–105.

Acknowledgments

For assistance in researching this book, my thanks go out to the staff of Chester County Archives (Laurie Rofini, Cliff Parker, and John E. Smith III), and Chester County History Center Library (Judy Ng, Kelin Baldridge, and Margie Baillie). I would also like to thank Christine Gaydos at the Delaware County Historical Society, Matthew Millison at Delaware County Archives, and Pauline A. Stanton at Erie County Historical Society. Mike Sharp deserves my eternal gratitude for illustrating some of the most heartbreaking scenes in the book, for which I had no other visuals. Finally, the inspiration for this book began in 2015 during research for Halloween tours at a remarkable living history site called the Colonial Pennsylvania Plantation near Media, Pennsylvania, and it is to that site and its staff and volunteers, whom I was proud to call my colleagues, that the most emphatic "thank yous" belong.